PARANORMAL
BURTON UPON TRENT

RICHARD O'CONNOR

AMBERLEY

First published 2024

Amberley Publishing
The Hill, Stroud
Gloucestershire, GL5 4EP

www.amberley-books.com

British Library Cataloguing in Publication Data.
A catalogue record for this book is available from the British Library.

ISBN 978 1 3981 1427 2 (print)
ISBN 978 1 3981 1428 9 (ebook)

Typesetting by Hurix Digital, India.
Printed in Great Britain.

Acknowledgements

Although my name is on the cover of this book, in many ways it is written by the people of Burton. Thank you to everyone who shared their stories with me directly, virtually or in the local newspapers. Without your stories, there is no book, so Paranormal Burton is dedicated to all of you.

I would also like to recognise the individuals who supported me in so many ways throughout the endeavour of writing my first book. Ian Holt is a gifted and talented writer who has given up much of his time to help edit my work, significantly improving the quality and clarity of the stories within. I must also thank my wife, Sandy, for her unconditional love, continuous support and encouragement. Thank you to the members of the Swadlincote Paranormal Team, especially Stephen Griffiths, for inviting me along with investigations in the early 2000s, sparking a burning passion for the paranormal that will last forever, and to photographer Simon Deacon. I also thank the other team members, Leanne Whiting and Chris Stevens, for making the often fruitless task of investigating the paranormal – and the countless hours spent shivering in dark and derelict buildings – an experience always to be enjoyed.

Several individuals have provided images and other information that has greatly helped in the production of this book, namely James Lafferty, Ian Webster, and Stephen Sinfield from the Burton Mail (Mail Remembers).

Thank you to the members of the Facebook group *On Memory Corner, Burton upon Trent*, especially Kim MacBeth in admin, who works tirelessly to collect, study, and share Burton's history with everyone, and the people at the Magic Attic in Swadlincote, who also do an incredible job of preserving the local history for future generations.

And lastly, thanks to you, the reader, for taking the time to engage with this book; it makes the many hours spent creating it worthwhile.

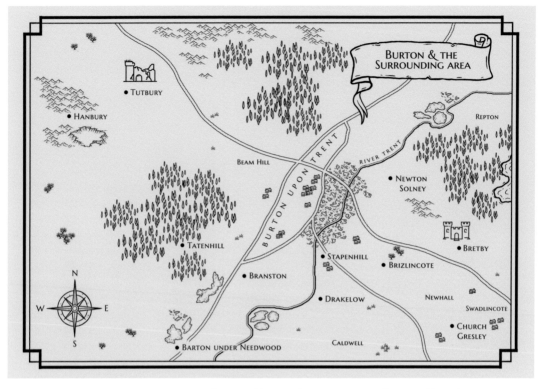

Burton & the Surrounding Area – Illustrated by Sandy O'Connor, with map effects from Fantasy Map Builder.

Contents

Introduction

People who say they don't believe in ghosts often tell the best ghost stories. Enthusiasts and paranormal investigators like myself can spend their entire lives searching for ghosts without ever seeing one, but the most intriguing of spooky experiences often happen to people just going about their daily business. For me, this makes their stories all the more credible, and I'm pleased to be able to share some of their fascinating tales with you in *Paranormal Burton*. There are no mediums or clairvoyants in this book, just real stories by people from Burton upon Trent and its surrounding area.

But why do some people see ghosts? Why don't we see ghosts of dinosaurs? Do ghosts even exist at all? In 2003, I joined Swadlincote Paranormal Investigations, hoping to answer some of these questions, but as I dived deeper into the subject, I found more questions than answers.

One thing I did learn, however, is that hauntings broadly fall into two distinct categories. The first is a Spiritual haunting, where the deceased's spirit still bears a consciousness and is yet to pass over to whatever lies beyond the living world. These spirits can interact with their witnesses, sometimes engaging in conversation or making themselves known by knocking something off a table or tinkering with light switches. The second type is a Residual haunting, whereby any ghosts observed are no more present than the actors in a movie you are watching at home. Instead, they are just moments in time echoing into the present day, stuck on repeat, unhindered by doors or walls that stand in their way. So, how can there be two types of ghosts rather than just one or the other? Like I said, more questions.

While scientists – or sceptics like myself – mostly believe that ghosts don't exist, I would say the fact that so many people experience them means, in some form or other, they do. Whether that existence goes beyond the confines of our imaginations is something we'll probably be debating for centuries to come.

Burton upon Trent has all the ingredients required for some fantastic ghost stories. Its extensive history begins sometime around AD 1002 with the construction of an enormous and powerful abbey. Its medieval bridge was the scene of two battles, first in 1322 and again in 1643, during the English Civil War. In the industrial age, Burton became the brewing capital of the world, producing around a quarter of all beer consumed in the UK at the time. Around the world, a treatment process called Burtonisation is still used to emulate the town's water, perfectly balanced for brewing the best beers, and Burton still produces some of the UK's most popular ales. Along the way, many important and influential people have lived or spent much of their time in Burton, from kings and queens to aristocratic families and senior politicians, not

to mention the tens of thousands of ordinary folks whose stories define the true soul and character of Burton.

So, in many ways, this book has been 1,000 years in the making, but now it's time to sit back and enjoy some of the best spooky stories from Burton upon Trent.

Let's cross the Trent Bridge into Burton to hear its spooky stories. (Author)

Burton upon Trent

Abbey Cottage

On the corner of Hawkins Lane and Horninglow Street stands an old brick cottage built sometime around 1830, now sadly boarded up but still retaining much of its original charm. A few years ago, a local man – who asked to remain anonymous – entered the building, more out of curiosity than anything else. As he was exploring the cottage, room by room, a feeling of unease grew within him; perhaps he was beginning to realise this was a place he wasn't supposed to be. Unnerved but determined, he ventured upstairs, and as he approached the main bedroom, the door violently slammed shut in his face. He ran out of the building as fast as he could. 'Served me right!' he concluded, never setting foot inside again.

Anglesey Road

One day in the 1970s, a young Kim MacBeth was walking home from Paget School with one of her friends and soon arrived at her mum's house on Anglesey Road. At the time, her grandparents also lived in the property next door, and the two houses, part of a dense terrace block, shared a communal entrance that ran from the road through to the garden. Kim knocked on the door, but her mum wasn't in yet, so the girls decided to pass the time chatting and playing games in the passageway. Inside it was dark with only a small amount of light at one open end. The original paint was heavily faded and peeling off the Victorian brickwork. The passage was also being used to store bicycles on the floor, along with dusty old wooden ladders suspended from the ceiling by hooks.

'Don't ask me why', Kim said, 'We began to chant numbers.' They started, 'One, two,' and continued in sequence. When they chanted 'eight', a deep, gruff male voice loudly said, 'Nine!' from somewhere in the darkness. The two startled girls looked at each other, eyes wide open with shock, and 'legged it up the garden', where they stayed until mum finally came home.

Harper Avenue

Sometime around 1953, a teenage boy was walking towards his home one evening along Harper Avenue when he passed the house of one of his neighbours, Mr Dykes, who stood leaning on his gate. As was usual for the boy, he said hello to the

gentleman, who returned the greeting but, on this occasion, Mr Dykes addressed him by his first name. The young boy found this to be a little odd as this was something the elderly neighbour had never done before, preferring instead to use his surname. When he reached his home just two doors away, he mentioned this encounter to his mother who, somewhat confused, informed the boy that Mr Dykes had passed away earlier that morning.[1]

Ind Coope Brewery

Whilst many of Burton's ghosts seem to lurk in its many pubs and alehouses, the breweries themselves also have a few spooky tales of their own. Ind Coope was established as a brewery in Burton in 1856 when Edward Ind – from Romford's brewing dynasty – entered into a partnership with Octavius and George Coope eleven years earlier.[2]

In 1975, electrical storekeeper Ray Middleton was making some toast in one of the old brewery buildings. He noticed a toilet door was open, so he closed it and returned to the stove to continue preparing his meal when he suddenly heard a loud noise. Ray turned to look and saw the door opening and banging shut on its own. Ray immediately shot out of the toom 'like a scalded cat' and described what he saw to a security guard. The guard went to investigate but found nothing untoward, so he switched off the lights. However, at the moment the room fell into darkness, he saw a grey-haired man standing at the end of the room. Startled, the guard instinctively turned the lights on again, but the grey-haired man was nowhere to be seen.

The British Oak

Burton's position as a major brewing centre can be traced back to the early twelfth century, when monks from Burton Abbey began brewing beer for the first time. By the early nineteenth century, Burton had become known as the 'brewing capital of the world' and was home to over thirty breweries and 163 pubs, clubs and alehouses. The town's brewing industry declined in the late twentieth century, but there are still several breweries in Burton today, including Molson Coors, Burton Bridge Brewery and Burton Town Brewery. The British Oak on Byrkley Street is one such pub that is sadly no longer open, but at least no one can blame the ghostly visitors for scaring customers away.

'It's a friendly and playful ghost that haunts the British Oak pub', reports the *Burton Mail* on 10 January 1990. Ken Cousins had taken over the pub the year before, and one day, only four months after moving in, one of the beer taps suddenly started pumping beer. Ken – who was working behind the bar – quickly grabbed a glass, managing to catch most of the drink, around half a pint. The same thing happened five more times in the coming days and weeks, each time half a pint. The electrically operated pumps were checked twice by experts, ruling out any malfunctions. Occasionally, the thirsty entity would pour itself a cider but, disconnected from the draught, the only thing coming out of the tap was the whirring sound of a dry pump.

One morning, the cleaner was carrying plates back to the bar when a fluorescent light fitting came crashing down in front of her, leaving wires dangling from the ceiling

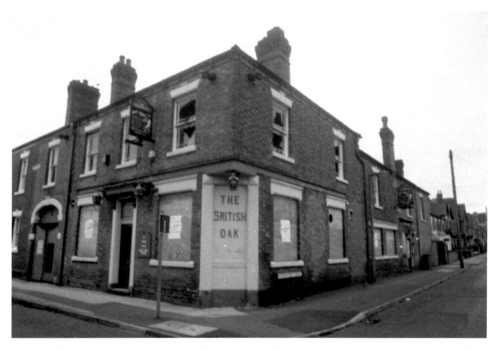

The British Oak is now one of many pubs in Burton that have poured their last pint, as seen here in 1994. It did later reopen as the Old Cottage Tavern but, at the time of writing, is closed again and set for redevelopment into housing. (Burton Mail c/o Stephen Sinfield, Mail Remembers)

as though ripped away rather than just becoming disconnected. Was this the work of the thirsty spirit, upset by the lack of cider? Or just a coincidence?

Ken and his wife would sometimes go into the cellar to find that the electricity and gas were switched off, preventing the drink from flowing to the taps at the bar, or switched on when the pub was closed. No one ever saw whatever was tampering with the switches in the cellar, but it was enough to make their dogs tremble with fear and run away if taken down there. Ken also noticed ashtrays moving from one table to another or disappearing altogether, and on at least one occasion, he turned off the lights and locked up the building to go out one night only to find them all switched on when he returned. Ken was confident that these were not the actions of any living person – making doubly sure that he locked all the doors and that no one else could go to the cellar. Whether the visitor is a former landlord or just a playful carouser of the past, they often left Ken feeling mystified but never afraid.

Burton Market Place and Hall

The cool February air seemed to amplify the clip-clop sound of the occasional passer-by, echoing between the walls surrounding the empty market place, before gradually fading away behind the distant hum of traffic crossing the Trent Bridge. It was evening and the traders had long since packed their tables away, leaving behind a quiet empty space, where only the rest of the paranormal investigation team members and I stood waiting by the entrance of the Market Hall.

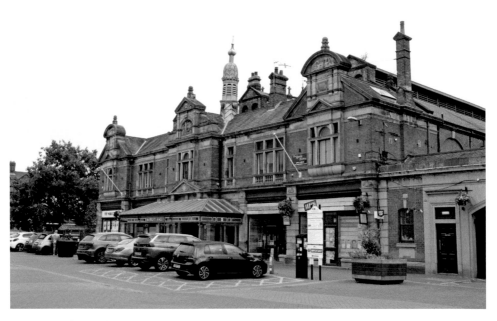

Burton Market Hall. (Author)

We admired this grand old building that has been hosting markets in Burton since opening in 1883. It was designed in a Renaissance style, with sandstone pillars and pediments worked into the red-brick facade. Above the main entrance are four carvings. The most prominent depicts King John handing a charter to the kneeling Abbott of Burton, allowing markets to take place in Burton. 800 years since this event and the weekly markets are still going strong.

The building manager arrived soon afterwards to unlock the large iron entrance gates, before welcoming us inside and locking them behind us.

Inside, the Market Hall is around half the size of a football pitch, with nine large trader's stands surrounded by more stalls against the walls. Above the outer stalls, a balcony circles the entire perimeter of the trading floor. Supported by eight thick iron pillars, each with ornate patterns cast into their girths, hundreds of small beams crisscross overhead to create a roof that wouldn't look out of place on a Victorian train station.

At this late hour of the day, and with the absence of any other people, the hall became an eerie place. Each of the stalls was obscured by a curtain, like dust sheets thrown over the antique furniture of an abandoned building. The feeling would have been greater had I known that the Market Hall was built directly over the cloisters and chapter house of the medieval abbey, where it is suggested the graves of abbey founder Wulfric Spot and his wife are buried.3

We made the most of the little remaining daylight to explore the building, familiarising ourselves with the featureless staircases and narrow passageways. We eventually chose a spot on the balcony, the most central part of the building, as a makeshift basecamp for our equipment and belongings.

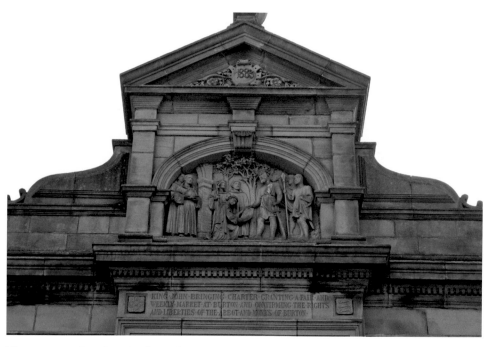

The stone carving that sits above the main entrance to the Burton Market Hall. (Author)

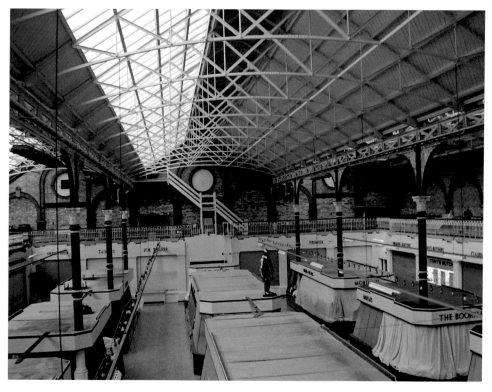

Inside Burton Market Hall after closing time. (Photo by Stephen Griffiths)

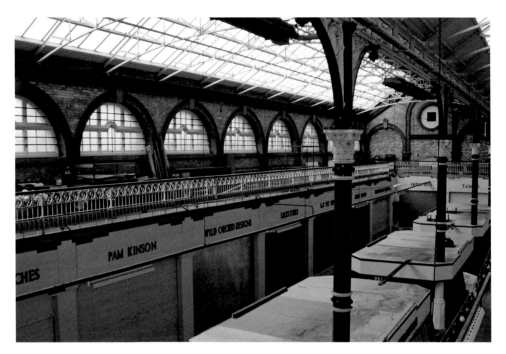

The balcony encircles the Market Hall floor, an ideal place for our base camp for the paranormal team's equipment. (Photo by Stephen Griffiths)

Our investigation started at around 8 p.m., speedily setting up cameras in the small damp basement and in the main Market Hall itself. However, most of our attention would be on the rooms above, once a bustling home for the hall's caretaker and his young family, now disused and left mostly empty. When we spoke to the current Market Hall staff, they admitted their reluctance to venture to this area alone, reporting feelings of unease, especially at the top of the staircase leading up to the living quarters.

We set up more cameras, whilst also conducting experiments, such as using dowsing rods and trigger objects (items left in position to see if they move on their own), but no significant paranormal activity was detected during this brief investigation.

By 10:30 p.m., with the halls now in total darkness, some of the team members and I made our way home. Simon and Stephen remained, busily packing away their equipment on the balcony basecamp. As they folded away their camera tripods, turned off the EMF readers and gadgets by torchlight, the main Market Hall lights suddenly started to flicker into life. Assuming the Market Hall manager had turned them on to assist with packing the equipment away, the two men shouted out an obligatory, 'Thank you!', imagining that he'd probably hear them, wherever he was. He never replied.

Around fifteen minutes later, however, the lights turned off again. The men smirked at each other and grumbled a sarcastic 'Thanks!', assuming that the manager was now rushing them to leave. Only seconds later, they heard a huge crash from somewhere beneath them. They looked over the railings but with the hall now plunged into darkness, it was impossible to see what could have happened. Again, they shouted out to the manager, this time concerned that he may have been injured in an accident.

One of the central living rooms in the attic area, with a trigger object by the fireplace. (Photo by Stephen Griffiths)

These rooms were once a home for the caretakers of the Market Hall. Keep reading to learn about some of the spooky experiences from one of its former residents. (Photo by Stephen Griffiths)

As they peered down into the darkness below, hoping for a response, they were surprised to see him appear through a doorway behind them after also hearing the loud noise. Realising none of them was responsible, they went downstairs to investigate the cause. As they neared the entrance, they discovered the investigation team's equipment that had already been taken down to the front door had not only been knocked over but scattered across the floor.

The manager, who confirmed he was in one of the upstairs offices at this time, said the lights were on a timer so should not have come on until 6 a.m. and then stayed on for a minimum of two hours thereafter. He had no idea why they turned on when they did that night, insisting he was never aware of them behaving this way in over twenty years of working there.

Finally, as the men were returning their scattered equipment and storage cases into order, they remembered a trigger object placed in one of the empty rooms upstairs. It was a small wooden cross, around 4 inches in length, placed on a sheet of white paper with its edges traced in pencil. When they found it, the cross had visibly moved to the right of the line that had been traced around it earlier that night.

This investigation took place in 2008 and is based on notes made by myself and by paranormal team member Simon Deacon.

In August 2021, I spoke with a Burton local, Alan Matthews, whose father worked as the caretaker of the building before retiring in 1975. Alan said he would have been around eleven or twelve when he and his family moved to live in the Market Hall.

It wasn't long before they noticed something strange about their new home. It started when his father was winding up the mechanism for the clock, using a narrow access hatch from the attic area. He felt a tapping on his back and turned in response, only to find that whoever had done it had vanished. This happened repeatedly, each time seemingly with no one else around. Convinced Alan was the culprit, his father blamed him and hard as he tried, Alan never persuaded his father it wasn't him playing a prank that day.

Over the following weeks and months, all the family members would begin to feel that they weren't alone in the Market Hall. The creepiest area was at the top of the stairs. 'No one liked to go up there,' Alan said. 'There was a cold spot and it just made you feel uneasy.'

It was a similar story with a storeroom accessed from these stairs. His father – whom Alan described as someone who wasn't easily fazed – said he sometimes felt something brush past him in this room. 'It always felt like someone, or something, didn't want you in there.'

The most central room of the attic area was used by Alan as a sort of club room. One day, Alan and three of his friends were in the room with their guitars and a tape recorder, 'just playing about, making noise'. This stopped abruptly when the doorknob at one end of the room could be heard turning. To their amazement, the door opened, but no one appeared. Instead, they heard footsteps walking along the wooden floorboards beside them, heading towards a door at the other end of the room. When the frightened boys played this moment back on their tape recorder, the footsteps could be heard very clearly. Unfortunately, the tape recorder fell apart many years ago and the tapes no longer exist.

It was during the night when the most startling experiences occurred for the family. First, it was his mother, who awoke one night to see a grey old lady standing motionless at the end of the bed. She battled through her fear and tried to speak with the apparition, but it gradually faded away in front of her. Sometime later, Alan too saw her in similar circumstances. He described her as an old lady wearing a frilly top and a long dress, who again appeared colourless, 'Just a silvery grey.' She too faded gradually, without any speech or noise.

The apparition of the old lady was occasionally also seen at other times of the day. One afternoon, Alan's father ran from the bathroom upstairs down into the living room, 'looking as white as a sheet', dripping wet with just a towel wrapped around his waist. He had been enjoying a warm, relaxing bath when the door slowly opened, and an old lady emerged from behind it. His father leapt out of the bath, grabbed a towel, and ran down the stairs as fast as he could.

As the years passed by, the family eventually became accustomed to these experiences and unafraid of the regular paranormal activity. They even nicknamed the old lady, 'Auntie'. Sometimes, when friends or family visited and strange noises were heard, they'd often say, 'Don't worry, it's just Auntie.' Unfortunately for Alan, Auntie caused him to lose a couple of girlfriends, who were not as comfortable with the spooky activity as he had become.

The most paranormally active parts of the Market Hall were the living area and attic rooms rather than in the main hall itself, but sightings outside of the building have also been reported. Alan and his friends were riding around on their bikes behind the building when one of them 'came belting back' towards the main group shortly after disappearing behind a wall. The boy asked his friends, 'Who is the old man dressed as a monk?' They rode to investigate, but the monk had vanished. Several market stallholders have also reported what they described as a monk in the same area.

Burton Market Hall is undoubtedly haunted, but why? Hauntings are normally associated with deaths, especially traumatic deaths, such as murders, but there isn't any documented evidence of this sort of thing ever happening.

One consideration is that it could be linked to the ancient stonework that lies beneath. Paranormal activity does seem to occur more often in buildings where renovation work or other significant alterations are being made, almost as if an energy – trapped in the fabric of the brickwork – is being released. This was so common that, during my own time as a paranormal investigator, it's one of the first things I would ask about if new phenomena had been reported to our team.

Perhaps for those who have witnessed paranormal activity whilst in or near the Market Hall, the source of it lies beneath their feet. However, with over 800 years of history, it's hard to imagine how many people have lived and worked on this land, making it hardly surprising that the Market Hall is amongst Burton's most haunted buildings.

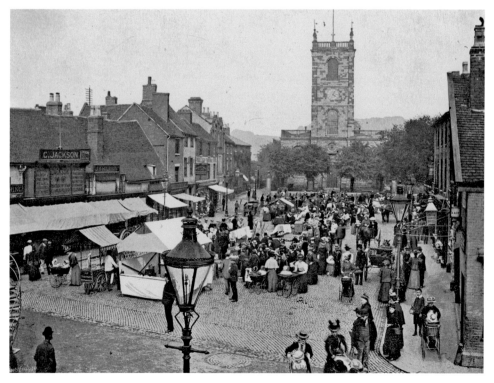

A busy day at the Outdoor Market in Burton, sometime during the early 1900s. The hall is just out of shot to the right, with St Modwen's Church (built 1728) at the rear. (Picture from 'Boots Fine Art Views of Burton', supplied by Ian Webster)

The Constitutional Club

With its many retail outlets, fine pubs and clubs, Burton High Street has always been a place where the locals can spend their recreational time. One particular building – once exclusively reserved for the town's elite to unwind – is the imposing Constitutional Club.

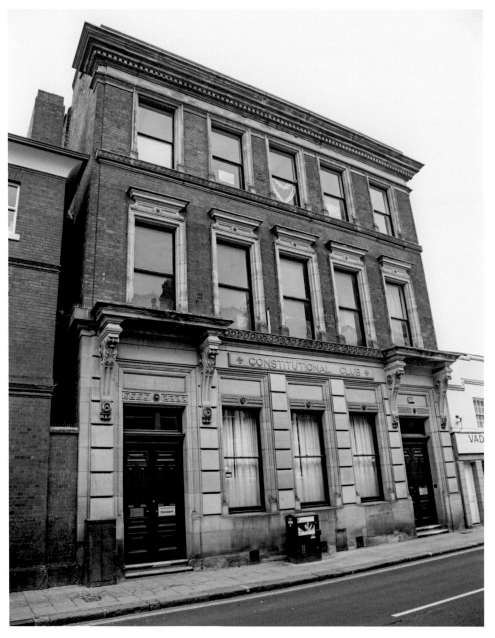

The imposing facade of the Constitutional Club on Burton's high street. (Courtesy of the Constitutional Club)

Steeped in history, the club was built within the grounds of Burton's medieval abbey, whose original thirteenth-century wall still marks the boundary at the rear of the club's bowling green. In the mid-1600s, an almshouse was built to provide accommodation for 'Six elderly honest widows or maids', before being demolished and replaced in 1874 with the current three-storey building. Adorned with finely carved ashlar stone architraves and cornices, its grand facade – resembling a bank – was actually the town's main post office. It is perhaps no surprise then to hear many stories from people who say they have seen the friendly postmaster, still busily working or walking around the building. The source of the sightings could be the original postmasters' shelving and storage units, complete with a penny slot and sloped postal trays, fitted behind the club's bar.

When the post office relocated to New Street in 1905, the building was quickly purchased by Lord Burton and Robert Ratcliff of the town's Brewing dynasty, to be converted into an exclusive gentlemen's club for the town's premier businessmen and politicians. Although the world has changed a great deal since then, with the club no longer reserved solely for the town's elite members of society, much of the decor remains as it was on the grand opening day in 1911. A great oak fireplace, carved by Burton's finest craftsmen, stands tall at the far end of the main room, once used for smoking, now home to several large snooker tables. Here, the spirit of a former member – described as a tall man – has reportedly been seen, casually leaning against the main ledge of the fireplace, tapping burnt ash out of his tobacco pipe.

No expense was spared during the conversion from Post Office to a private members' club. An impressive stained-glass window in the stairwell welcomes guests. (Courtesy of the Constitutional Club)

Nearby, a single lavatory door – single as there was once no need for ladies' toilets – leads to the restroom, where, in the 1920s, it is believed a gentleman called Bill died from a fit or seizure. Bill makes himself known to visitors by getting up to mischief and generally being a nuisance. A lady, cleaning the room before an event, became increasingly annoyed when someone kept switching off her vacuum cleaner, but, since no one else was around, was equally baffled as to the culprit. When preparing for another event, caterers carefully arranged the placement of fine cutlery on a large dining table, before leaving for a short break, only to find on their return a few minutes later, it had all mysteriously rearranged itself.

Not all strange goings-on are paranormal, as a local paranormal investigation group discovered one evening in the early 2000s. They were using EMF meters – small devices designed to pick up electrical signals. Often used by investigators to help explain weird feelings more logically, these meters locate sources of electricity; they are also believed to spike when spirit energy is detected. On this particular night, the investigators were excited to see their devices spiking when they knew there were no wires or plugs behind the historic, oak-panelled walls. Eventually, the mystery was solved when one of them discovered that the snooker table was heated electrically.

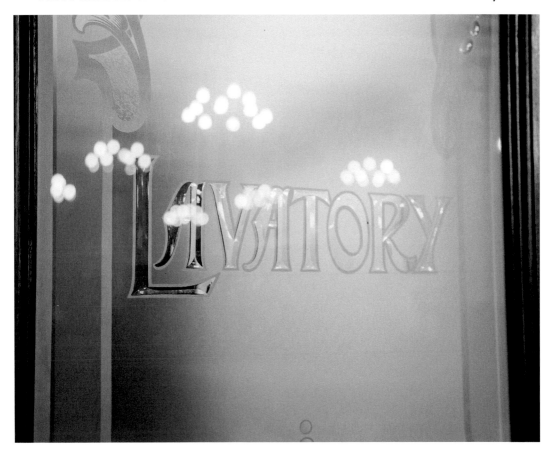

The club opened in 1911 as a men's only club, so no need for separate gents' and ladies' toilets at the time. Fortunately, the club has moved ahead with the times. (Courtesy of the Constitutional Club)

The lavatory door and fireplace where two spirits have been seen. (Courtesy of the Constitutional Club)

Gough Side

In 1993, Burton General Hospital treated its last patient before closing forever, bringing to an end 124 years of providing healthcare to Burton locals. It was swiftly demolished to make way for Gough Side, a modern housing estate described by some residents as one of the most haunted in Britain. In 1997, several families shared their experiences with the *Burton Mail*, suggesting that despite no traces of Burton's old hospital remaining, not all the former staff and patients were willing to leave it behind.

Strange goings-on affected residents of all ages, including Miranda, a seventeen-year-old student, sitting in her family living room when she glimpsed a figure walking through their kitchen. At first, she thought it was her mother, but she was in the bath upstairs. Her younger brother, the only other person in the house, was asleep beside her on the couch. Angela, her mother, also recalled unexplainable events in their home. One night, her ten-year-old son shot up in his bed, screaming in fear, before quickly darting downstairs to tell his mother he saw the vision of a 'bright shirt' floating in the room with him. Although this and many other occurrences – scratching noises, lights turning off, a mug falling off a dresser for no reason – initially left the family feeling spooked, Angela thought about her father who, ten years earlier, died in the hospital. Perhaps it was his spirit, lovingly watching over his young family.

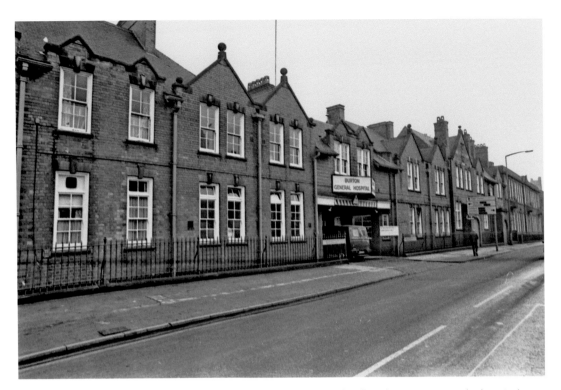

The New Street entrance to Burton General Hospital. Shortly after closing in 1993, the hospital was demolished to make way for new buildings, including the Gough Side housing estate. (Burton Mail c/o Stephen Sinfield, Mail Remembers)

In another Gough Side household, Lynn Dennett spoke of doors inexplicably opening, even when they had been closed securely with a latch, and of hearing door handles clicking and rattling as though someone was trying to open them. Lynn's most frightening experience happened when she was ironing: 'I looked into the hallway and saw somebody come downstairs and go into the toilet; it just walked straight through the closed door.' Lynn could hardly believe her own eyes. Lynn's husband and five-year-old son also claimed to have witnessed apparitions. One night, Lynn's son ran into her bedroom screaming, 'I've just seen a ghost!' She told her young son that there was no such thing, all too aware of her own experiences but trying to avoid frightening him further. 'It has taken me a long time to get him back into that bedroom,' Lynn asserted.

The oldest resident to share tales of spooky experiences was seventy-eight-year-old Eva Broadhurst. Her visions were much more vivid than the fleeting glimpses and unsettling noises experienced by her neighbours. Her first visitor appeared to be a former nurse, described by Eva as a lady around sixty years of age, quietly standing at the bottom of her bed one night. 'She was dressed in blue with short, fair hair, and a round face, and a lovely smile.' After that, Eva saw former patients, including an elderly lady dressed in nightwear, sitting silently in her bedroom's dark corner. The frail patient appeared to hoist herself up on a walking frame and shuffle slowly across the room before disappearing. Two nights later, the same thing happened again, except this time it was a male patient on walking sticks.

Eva witnessed many apparitions in her new home, but never the same one twice. Fortunately for the pensioner, none of the spirits she saw caused her any concern. On the contrary, Eva told reporters she was happier than at any other time in the previous eighteen months, before moving to Gough Side. 'I'm not afraid of ghosts,' said Eva. 'It's the living who could do the damage. Ghosts can't hurt you.'

Grail Court Hotel

By the early 1800s, business was booming all across Burton. With the expanding breweries came a railway network that once ran through the heart of the town, and local entrepreneurs built hotels close to the tracks to accommodate travelling businessmen and tourists. One such hotel was the Midland Hotel, better known in later years as the Grail Court Hotel. In the twenty-first century, the hotel was regarded as one of the most haunted buildings in Burton, with over twenty ghost-hunt or psychic-themed nights per month at one point. The hotel is also featured in Derek Acorah's book *Haunted Britain* as one of the UK's 100 scariest places to visit.

The gentle thudding of footsteps darting across the floorboards became a familiar noise to many former staff workers, including two working in the cellar late one night as part of a refurbishment project. However, when they left the cellar to see who was making the noise, they found no one else in the building. Guests have also been kept awake by the joyful laughter of playing children, and a young girl wearing a white nightdress has been seen running up and down corridors at night on several occasions.

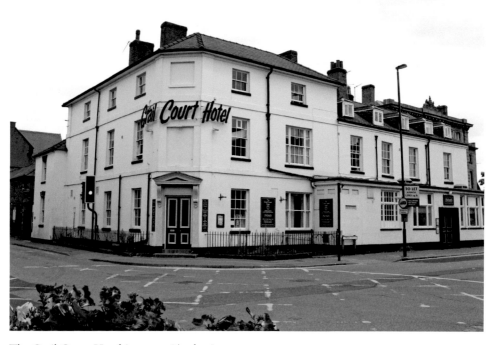

The Grail Court Hotel in 2022. (Author)

It's unknown if the playful child is responsible for the red crayon marks mysteriously appearing on the bathtub in room 21, where faces have also been seen from the outside, peering through the window to the busy street. Researchers from the BBC decided to spend a night in this room to see if they could experience the hauntings for themselves. After checking the bath for crayon marks and closing the curtains, they went to sleep. Soon after, they were woken by the sound of the young girl laughing in the corridor outside their room. The researchers opened the door and scanned the hallway carefully with their sleepy eyes but, sure enough, found no sign of anyone, so they went back to bed but were soon woken again by the same noise. This time, they discovered that someone, or something, had opened their curtains, and the bathtub was marked with a red crayon.

An old stable block to the rear of the building, now used for storage, is no less haunted. A heartbroken stable hand, stricken with grief, has been seen hanging from a beam in his final, tragic moments.

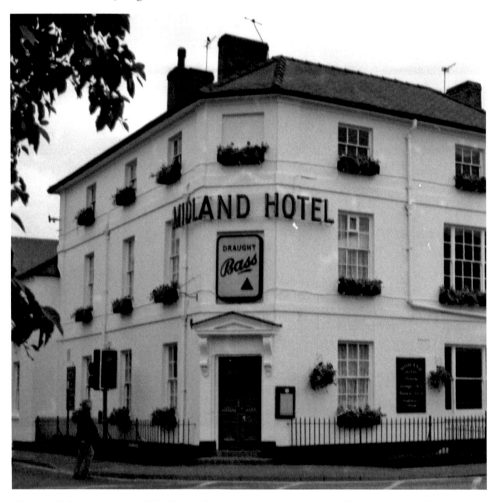

The Grail Court Hotel will be better known to many as the Midland Hotel until it changed names when it reopened in 2000. The picture was taken in 1996. (Burton Mail c/o Stephen Sinfield, Mail Remembers)

Holy Trinity Church

The chiming of bells is a common sound in Burton and to the untrained ear, the ringing of a bell from a church long since demolished would most likely go unnoticed. In April 2012, however, two local bell ringers with an ear for every bell in town were walking through King Edward Place when they heard the sound of a bell that was unfamiliar to them. This was neither the bell of the nearby Town Hall nor that of the church of St Modwen's.

Instead, the chimes seemed to be coming from the direction of the Aldi supermarket that stands on the site of what was once the old Holy Trinity Church, which was demolished in 1971. Could the sound of the bells, long since destroyed, still be heard in a ghostly echo many years later?

Jerry's Diner, Worthington Walk

Another one of Burton's once cherished but sadly lost establishments is Jerry's Diner on Worthington Walk. The 1950s-style American diner made headlines in March 1995 when some staff became spooked by apparent poltergeist activity. I say poltergeist because the ghost was never seen – or heard – but made itself known by moving or throwing things in the cafe.

Mrs Joy Murch, one of the workers, described seeing things jumping about or falling off tables, including a mug that hopped over the teapot and onto the floor. Most strange events occurred at around quarter past three in the afternoon, usually

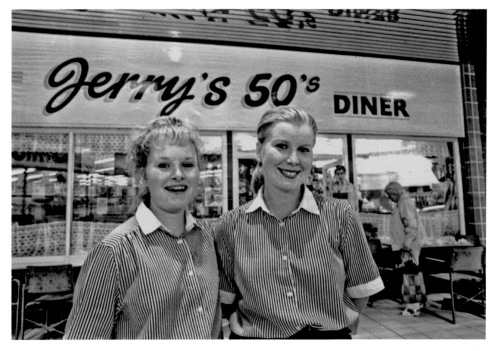

Jerry's Diner – pictured here in 1991 – was a popular 1950s diner on Worthington Walk. (Burton Mail c/o Stephen Sinfield, Mail Remembers)

in the staff-only areas, including behind the bar, where a tin lid jumped up off a table and hit a young girl. On other occasions, the staff would find the microwave and grill switched on, even though the power switches were off.

'We've had an electrician in, and he says there is nothing wrong with them,' said another worker. We will never know who was behind the strange goings-on, but the strong smell of perfume noticed by Mrs Murch led her to believe that it could have been the spirit of a lady. Either that or the novelty of milkshakes, burgers and jukeboxes were too irresistible, even for the dead.

The Leopard Inn

Few buildings in Burton can compete with the unique aesthetics of the Leopard Inn. The red-brick building thrusts forward on the corner of Lichfield Street and Abbey Street, a mere footpath's width from the edge of each road. The three-storey building features a dark green wooden facade on the ground floor, with four individual cream panels on the levels above. Each panel, embossed with gold lettering, proudly announces the pub's name, along with some of the drinks served when it was a tap house for Charrington's Fine Ales. The brewery has long since been demolished, leaving a vast open space to the rear of the pub, but the London-based brewer's name still reads across the roof parapet. Compared with the retail park to the rear and the modern college building opposite, the Leopard Inn feels like an isolated, anachronistic symbol of Burton's heritage.

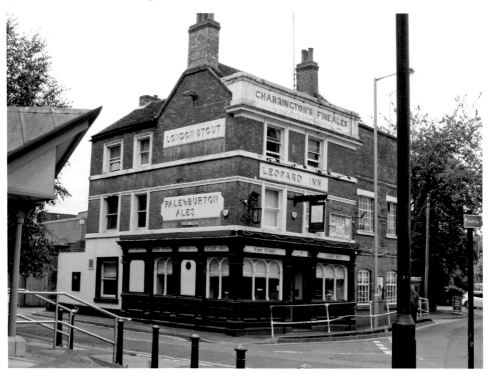

The Leopard Inn. (Author)

Despite its age, surprisingly few ghost stories have emerged from the Leopard Inn, but one intriguing tale featured in the *Burton Mail* in January of 1980. After five years running the Leopard Inn, Ken and Rose Cooter shared some of their spooky experiences, having recently moved from Burton back to their original hometown of Tamworth. The previous owner, Mrs Lewis, told them of hearing noises – like skirts rustling – from the passage to the cellar. The couple thought little of it until one night, at around 11:30 p.m., after the pub was closed while getting some bottles from the pub's cellar, Mrs Cooter heard a similar noise – the unmistakable swish of a large skirt against a wall. She quickly stepped out of the cellar to the passage from where the noise seemed to emanate, but found no sign of anyone. Thinking she must have imagined it, she went back to the bar, chatting with two boarders staying that night at the Inn. Only ten minutes had passed before one of them also heard what sounded like a skirt rustling and swishing with movement, and saw the shape of a figure pass the bar area. More curious than frightened, he got up and switched on some lights to get a better look, but found no one.

On other nights, Mrs Cooter could hear footsteps in the rooms above, despite knowing they were empty. On another occasion, she and two others heard the heavy cellar passage door open and slam shut. However, it seems not everyone is spooked by The Leopard's ghostly goings-on. When the new owner, Mr Coopey, was asked if he felt uneasy about the haunted tales, he said he was more interested in the liquid spirits that fill up the till than the spirits he can't see.

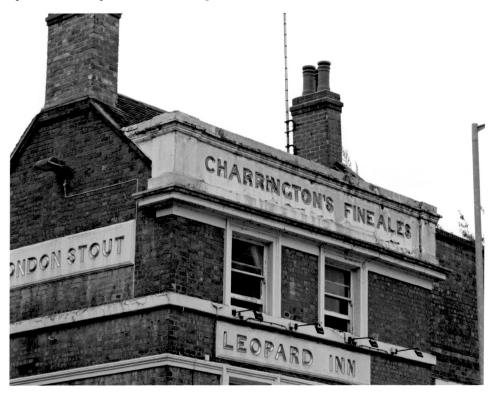

The unique facade of the Leopard Inn. The names of other breweries have appeared at the top of the building over the decades, but now its original identity has been returned. (Author)

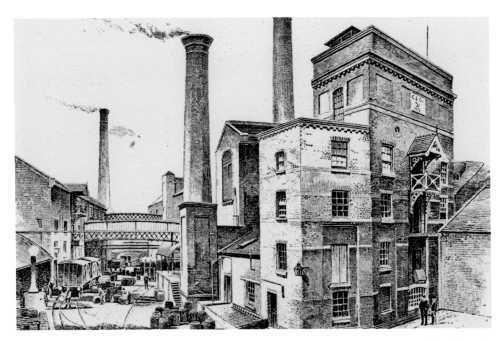

The Leopard Inn was previously a tap house for the vast Charrington's Brewery. The pub is the only part of it still standing, with most of the land now a car park and modern retail buildings. (Picture from 'Boots Fine Art Views of Burton', supplied by Ian Webster)

Newton Road

It was in the middle of the night, sometime during the 1970s, and a couple were driving along Newton Road when an unexpected encounter left them feeling more than a little shaken. As they neared the Burton Bridge, a woman dressed in what appeared to be Edwardian clothing stepped out in the road just in front of the car, seeming to appear from nowhere at all. The car swerved violently to the side, its driver desperate to avoid a horrible accident. Moments later, they stopped the car, and both got out to check on the woman they nearly hit, but she was nowhere to be found.

Old Royal Oak

Built around 300 years ago, The Old Royal Oak, one of Burton's oldest pubs, was in the 1800s a lockup for the town's crooks and criminals. It is rumoured the cellar still features cells where prisoners were once incarcerated. The entrance to the three-storey, half-timbered building faces the market place, close to where the great abbey once stood. A tunnel – now blocked – connected the Royal Oak to the abbey crypt. A local myth tells that the pub's name alludes to an ancient oak tree in the market place where condemned prisoners were led from their cells to be executed by hanging from its boughs. The truth is that the name is derived from King Charles II, who escaped from the Battle of Worcester during the English Civil War before his ascension to the throne and hid in an oak tree in Bishops Wood. The modern-day village of Bishops Wood has its own Old Royal Oak pub.

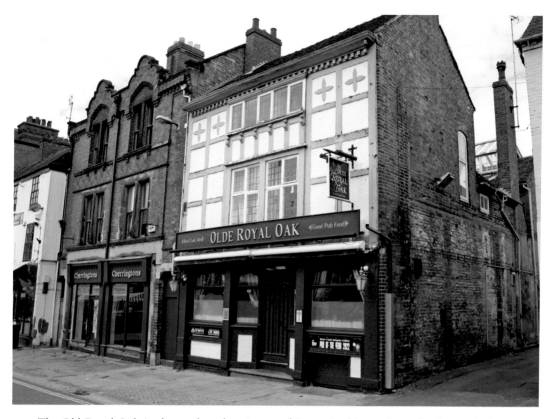

The Old Royal Oak in the market place is one of Burton's oldest pubs and a former lock-up for criminals. (Author)

Its colourful history and reputation for hauntings make the Old Royal Oak a popular stop for ghost walks. Arthur Roe shared some particularly spooky personal experiences during one of these events. As he followed the group, walking through an alleyway from the high street towards the pub, he noticed that a lamp post to his left started flickering and then turned off completely. Immediately after Arthur passed, it gleamed back into life. He thought it was strange as the same thing had occurred a week earlier, but he put it down to coincidence.

The group entered the Old Royal Oak, and while Arthur rested on one of their oversized chairs, the other ghost hunters walked around the main bar area with their paranormal gadgets, taking pictures and watching LED lights bounce around on their EMF meters. A barman sat down next to Arthur to tell him that earlier he had been behind the bar area putting drinks in the fridge when he felt a forceful kick from behind, so strong it knocked him over. The barman swore no one else was around and that this was not the first time it had happened. Later on at the event, whilst Arthur was telling a lady ghost hunter about the flickering lamp post, she exclaimed, without any preamble, 'He is sitting next to you.'

'Who is?' Arthur asked.

'A big fellow; he likes you but not the barman,' she replied.

She went on to describe the presence seated beside Arthur as a tall man, wearing dark clothing, like that of a former police constable from the pub's jailing days.

After the event, in the early morning hours, Arthur, walking down Andressey passage, saw the outline of a man, around 6 feet 6 inches tall, standing near the flickering lamp post.

Those who have lived in the pub have first-hand experience of its non-liquid spirits, including a Mr Banks (not his real name), who became a licensee in the late 1970s. Soon after moving in with his family, he heard unexplained noises and found lights he had switched off mysteriously turned on again in the middle of the night. He also described a strange and unwelcoming atmosphere, a feeling far too uncomfortable for one group of his guests. Some friends he invited to stay spent the night in the first-floor living room due to the pub's guest rooms being full. He woke the following morning to find them downstairs, bags packed and eager to leave. When asked why, they told Mr Banks they were kept awake all night, convinced someone else was in the room with them. Eventually, even his own mother refused to stay there. 'She absolutely hated the place,' Mr Banks remarked.

Claire Louise, a former bar worker at the Old Royal Oak, shared some of her experiences with me. One night, she locked up after closing time and, with the landlady's daughter, was playing on one of the fruit machines. Noticing a shadow emerging from behind them, Claire turned around to see who it was, but the only other people in the building, the pub's owners, were sitting at the other end of the room. Claire turned back to the machine, and her friend confirmed that she also thought someone was behind them. Claire would probably not have read too much into this one incident had it not been for regularly seeing glasses, despite being nowhere near the edge, falling off the bar and tables, and the sounds of chairs and furniture moving around the bar beneath their rooms in the middle of the night.

Another lady, whose brother also worked at the old pub, described feeling particularly strange on the upper floors of the building. Sometimes, out of the quietness of the night, loud music would suddenly start playing in her brother's room, and his keys would go missing, only to be found later in unusual places, such as down the shower plug. She also experienced the broken glasses phenomenon, except one morning, they found most of the glasses placed in the middle of the bar after locking up now laying shattered into pieces on the floor.

The Prince of Brewers

The Prince of Brewers is one of many popular pubs along Burton's high street, enjoyed by the locals day and night, but take a seat at the wrong table and you could end up going home with a wet lap.

Built within the abbey walls, it was previously the site of the Star Inn – which had its own brewery at the rear – later becoming a hotel before being demolished (date unknown) and replaced with the present building known over the years by many names including The Galaxy, The Beehive, Barnaby's and The Lounge.

Social media users reported paranormal activity spanning several decades. Some said they had been in the toilet area applying makeup in the mirror when another person suddenly appeared next to their reflection, only to vanish when they turned around to look for them. Others spoke of glasses that appear to move mysteriously on their own. I contacted the current owner, Sally, who said she also noticed this

strange phenomenon despite only occupying the building for around six months. She described seeing drink glasses moving on CCTV footage of the bar area. Most of the time, the movements are small and probably go unnoticed by most people, but sometimes the mysterious actions are far too large to be missed.

One customer was sitting at their table when, moments later, their freshly filled pint glass suddenly slid off the table onto the floor. Certain they hadn't bumped or even touched the table; they shouted, 'Oh my God! It just flew off.' Another customer was less than amused when, sat at a different table, a full pint glass suddenly flew towards them and into their lap. With his trousers completely soaked in lager, he loudly moaned, 'This place is haunted!' before getting up and leaving.

Keen to keep her customers happy, Sally has checked the tables thoroughly with a spirit level, only to find them all sturdy and level. So next time you visit the Prince of Brewers, remember to keep an eye on your drink.

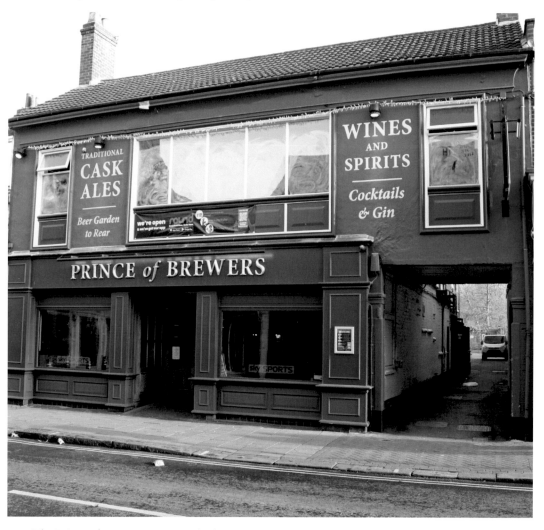

The Prince of Brewers in 2022. (Author)

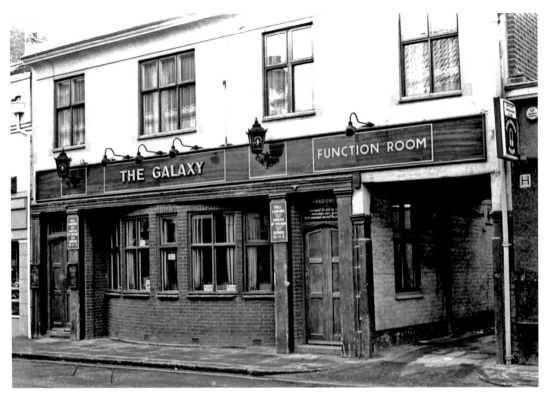

The Prince of Brewers was previously known by many names, including the Star Inn, The Beehive, Barnaby's, The Lounge and The Galaxy, as pictured in 1987. (Burton Mail c/o Stephen Sinfield, Mail Remembers)

The Ritz (Odeon/Robins Cinema)

The Ritz is a place I shall forever associate with many fond and haunting memories, albeit not through any personal ghostly encounters therein. It opened in 1935 as a cinema, furnished with contemporary art deco-style mouldings on the walls and ceilings, with a large central stage viewable from both ground-floor seating and balcony levels. After sixty-five years of entertaining local film fans with the latest movie releases, sadly and for the last time, in December 1999, the curtains drew to a close across its silver screen. Many locals still refer to the building by one of its many former cinematic names, including the Ritz (1935), Gaumont (*c.* 1957),[4] Odeon (1966) and finally, Robins Cinema (1996). Ten years after its closure, donning breathing masks and protective gloves, the Swadlincote paranormal investigation team and I ventured inside.

Instead of apparitions and other spooks, we found scenes of extreme dereliction and the foul mess from a decade of pigeon inhabitation. Having all enjoyed watching movies at the cinema, the state of disrepair into which it had fallen in just ten years saddened us. Fortunately, the old Ritz was restored and opened as a World Buffet in 2014 before reopening as an events venue a few years afterwards.

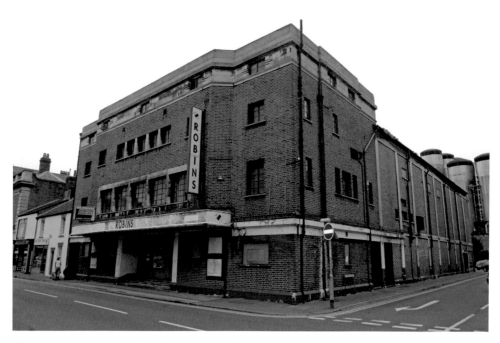

The Ritz was the home of Robins Cinema from 1996 until it closed in December 1999. It is seen here in 2009. (Author)

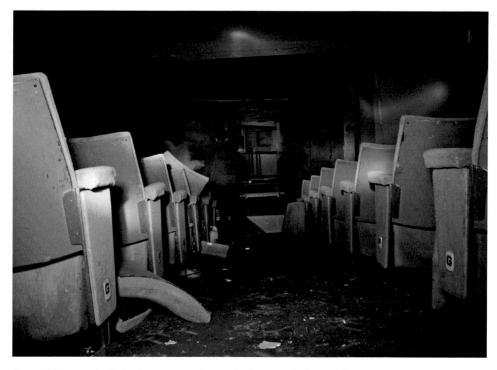

Screen Two was built in the space underneath the main balcony. The projection screen was removed after the cinema closed, leaving a cavity in its place, as seen here in 2009. (Author)

The chairs of this cosy screening room have been empty for over a decade, with pigeons and shadows their only companions. (Author)

Remnants of projector film were scattered around the building, including an old storage room behind the small ground-floor screen. The doorway to the bottom left of the image leads directly to the stage and main screen. (Author)

The main screen, too, was in a decrepit state, torn in many places and falling away from the ceiling. A sad way for part of the town's heritage to end its days. (Author)

Considering the thousands of people who visited the building over the decades, it is unsurprising to find that the echoes of its past still resonate today. Local paranormal enthusiast Dave Aisthorpe shared some anecdotal accounts of spooky sightings and sounds from the Ritz. A lady who worked at the cinema in the 1990s described seeing a grey-haired man, wearing a suit, standing near the main screen after closing time; she could also, at times, hear people talking in the bar area, despite there being no one else on the premises. More recently, another staff member recounted hearing a man's voice repeat 'Hello' loudly enough to hear through her headphones, but when she turned around, found no one.

The main stage area seemed to be a focal point for activity, with many reports of the sound of footsteps crossing the stage or of a strong smell of cigar smoke. One of the strangest happenings involved a six-year-old girl running around by the main stage area, who kept stopping and staring into an empty space. When her mother asked the little girl what she was doing, she said she could see a scary-looking man standing on the stage.

There is a local wartime legend of a young Burton girl having an affair with an American airman. They spent a lot of time together at the Ritz, dancing the night away, falling deeply in love with one another. One night, she kissed her lover goodbye but sadly he never returned to her; presumed killed in an air crash. Her anguished spirit was – reportedly – sometimes seen wandering around the dancefloor, desperately searching for her lost love.

The main projectors that beamed movies for many decades onto the larger Screen One in the main auditorium. (Author)

We carefully weaved our way between the rows of worn and moulding seats, but found no ghosts during our visit. (Author)

After being empty for only ten years, the interior of the building was in a terrible state. Fortunately, it has since been rescued and is now a thriving events venue that can once again be enjoyed by the people of Burton. (Courtesy of Simon Deacon)

Sinai Park House

Through a small gap between the terraced houses of Shobnall Road, a narrow lane ascends across open green fields, once part of a large deer hunting park, now home to sheep who graze freely around the rich meadow pastures. At the top of the hill stands Sinai Park House, Burton's oldest and most haunted building, where, ahead of an overnight visit, I anticipated the experience of meeting at least some of the fifty ghosts reputedly residing there.

The house was bathed in the late afternoon sun, highlighting all the fine details of its lattice timber-framed wattle and daub structure. But whilst the beautifully restored north wing would look fitting on a picture postcard, most of Sinai House lies in a state of derelict disrepair, adding to its unique character.

The warm, friendly smile of the current owner, Kate Murphy, greeted me as we commenced our tour, starting outside the building. The first stop was a chalybeate spring around 100 metres in front of the house. Like the better-known Chalice Well, at the foot of Glastonbury Tor, this rare type of spring, containing salts of irons, was believed to possess healing qualities. The presence of this spring made it a prime site for the original manor house, built in the thirteenth century by the de Schobenhal family, of which only the shallow moat and some cellar brickwork remain.

The prominent position of the site overlooking Ryknild Street – a route now followed by the A38 – suggests it may have also been used by the Romans, especially since it happens to be a day's march between the two major settlements of Derby

The North Wing of Sinai Park House in 2020. (Author)

and Lichfield. Not only would the hilltop position of Sinai have given the Romans a commanding view of the Trent valley, but the natural chalybeate spring would have provided them with an important source of drinking water.

Passing over a small moat bridge – built in the 1700s from local red brick – we made our way back towards the house. Kate told me about the origins of this unique building. Sometime during the 1300s, the de Schobenhal family donated the land to Burton Abbey to be used by monks as a place for recuperation from bloodletting. During this ancient ritual, up to 4 pints of blood would be drained from the body in the belief that so doing provided benefits such as longevity, suppressing sexual desire, sharpening the senses and even improving their musical voice. This process of extreme bloodletting, endured by the monks several times a year, required a break from their normal duties: Sinai House was used to serve this purpose. The original name may have been derived from the French word 'seyne' meaning 'blood', with Seyne Park recorded in writing as far back as 1410.[6]

Sinai's most well-known ghost, the Grey Lady, a servant from this time, looked after the monks during their period of convalescence. It is believed she entered into a secret relationship with one of the monks, who upon discovering that she was pregnant with his child, murdered her to hide his sins. Her body is rumoured to be buried in a nearby field under a tree, cut down in the 1960s. She often appears, an opaque grey figure, standing on or near one of the moat's bridges. Kate told me that although the apparition is often seen on New Year's Eve, others – previously unaware of this tale – have on numerous occasions witnessed a 'Grey Lady' in the gardens during the middle of the day.

The 1732 moat bridge leading from the house to the chalybeate spring. (Author)

The murderous monk's spirit is reputedly trapped inside a tunnel, once used for safe passage between the house and the abbey. This mysterious tunnel has itself become a local legend, with many Burtonians believing in its existence. No trace of it has ever been found. In reality, it is hard to imagine how a tunnel could have been constructed underneath the River Trent – given the boggy marshland around the abbey and the ascent to Sinai House. Rather than being a literal underground tunnel, a more likely explanation, proposed by Kate, is that the term 'tunnel' could in this instance be an old reference for a safe overground route through potentially dangerous marshlands, or a 'green tunnel' created by the overhead canopies of trees.

We continued on our lap of the grounds, inspecting the ruined part of Sinai where wooden beams, each of them subjected to hundreds of years of British weather, stand precariously within a vast web of scaffolding. Even if it wasn't far too dangerous to try to enter the buildings, thickets of saplings shooting through the interior floor make it impassable.

Stepping inside the restored part of the building, the surroundings would have been familiar to those who owned Sinai after Henry VIII's Dissolution of the Monasteries. The estate was given to William Paget, one of the King's most senior advisors, who eventually amalgamated the two oldest timber structures to create a grand hunting lodge. Many generations of the Paget family would entertain themselves and their friends with hunting trips and parties, retaining ownership of Sinai House until around 1900. Kate told me that on several occasions, both she and her husband, lying in bed late at night, have heard faint chatter and music apparently from parties on the ground floor. She also has first-hand experience of one of Sinai's other famous hauntings, the Black Dogs, who may have lived there during these hunting lodge days.

Dense thickets of saplings shoot up through the floors. The brick-built extensions were added by the Paget family. (Author)

(Author)

Her first sighting occurred inside the house, with a single dog running away into their living room. She and her husband owned black labradors at the time who weren't allowed in this part of the house and Kate complained to her husband for forgetting to close the door. Quickly protesting his innocence, it soon became clear that their dogs were all accounted for – none of which were in the living room.

The second sighting, a fleeting glimpse, took place outside of the building. Kate described seeing a black dog disappear around a corner of the house as she walked through the gardens. Others have seen black dogs inside the building, sometimes reportedly sitting with a group of Cromwellian soldiers as they relax by a warm fire.

This is possibly a residual haunting, whereby the ghosts are a snapshot of a brief moment in time playing over again – in this case from either just before or after a Civil War skirmish on the site of Sinai Park. This engagement between the opposing sides may have been brief, but its scars have remained down the centuries. Shot/spent musket balls having only recently been pulled from the wooden beams of the structure.

The large stone fireplace, enjoyed by the small group of soldiers, is in one of the central rooms of the surviving building, which also features classic examples of taxidermy, old guns and oil paintings of horses and hounds along with many other nods to the site's past as a hunting lodge. It is in this room where perhaps the most famous ghost of Sinai, Henry William Paget, 1st Marquess of Anglesey, has been seen (and heard) on many occasions.

Henry, a heroic military leader, commanded the Heavy Cavalry at the Battle of Waterloo, playing a pivotal role in ending the Napoleonic Wars. As the battle was ending, Henry, riding alongside the Duke of Wellington, was hit by case shot, shattering the lower half of his right leg. According to the famous anecdote, he exclaimed, 'By God, sir, I've lost my leg!'

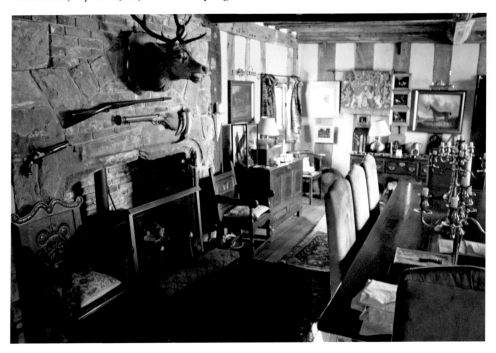

The large stone fireplace was once enjoyed by Cromwellian-era soldiers and their dogs. (Author)

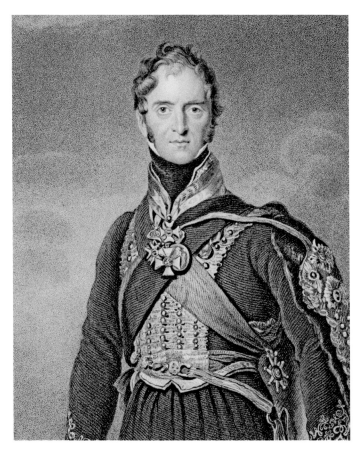

Henry Paget, 1st Marquess of Anglesey (1768–1854), was likely a frequent visitor of Sinai Park House, then a hunting lodge owned by his family. The last Paget to own Sinai House was the eccentric Henry Paget, 5th Marquess of Anglesey (1875–1905), who sold the estate after accumulating massive debts during his short life. Picture engraved by S. Freeman in 1846.

To which Wellington replied, 'By God, sir, so you have!'

Thereby establishing Henry's reputation as being fearless and composed even during the most extreme circumstances. He also had a reputation for taking an overly keen interest in women. He was even challenged to a pistol duel by the brother of his second wife after they scandalously eloped. Fortunately for Henry, his opponent's aim was off.

It's perhaps no surprise that the ghost of Henry Paget at Sinai is most often felt by women. Some describe being touched, although not in an inappropriate or threatening way, but as if trying to get their attention – a tap on the shoulder or a gentle brush along an arm. In what is now the dining room, he has been heard marching back and forth across the oak floors, possibly drawn to the layout and decorations that would have been familiar to him during his time at the house. A portrait of Henry now hangs proudly on a wall in the cosy living room area, a room where curtains have been seen to open or draw themselves closed, and the scent of pipe smoke can sometimes be smelled.

As evening approached, I made my way to the top-floor guest room, to spend a couple of hours writing down everything I had learned from Kate about Sinai House. Wondering whether I was to experience any of the ghostly sounds and sights about which Kate and I had been chatting during the day, I eventually got my head down and after keeping an eye and ear open for a while, fell into what became a deep slumber, undisturbed by any of the famous ghosts of Sinai Park House.

Sinai Park House in 1974, derelict but with the structure still relatively intact. (Burton Mail c/o Stephen Sinfield, Mail Remembers)

After being sold by the Pagets in the early 1900s, Sinai House was converted into cottages until contaminated water forced it to become abandoned. It was then used as a farm building before falling almost completely derelict until Kate took ownership of it. (Burton Mail c/o Stephen Sinfield, Mail Remembers)

Sadly, most of the building is now in a desperate condition, but the current owner is undertaking an ambitious plan to rescue it before it is lost forever. (Author)

(Author)

The Uxbridge Arms

Broken pint glasses are not uncommon behind a busy bar, but even for a novice, the new barmaid at the Uxbridge Arms seemed to be breaking more than her fair share. Her fellow bar staff joked that she was extraordinarily clumsy, but she swore they fell from the shelves of their own volition. Not long afterwards, however, glasses were breaking near them too.

'At first, we put it down mainly to vibration,' said Lorraine, the current landlady. But, as she explained, most breakages happened later on, in the evening, when the road grew quieter. A truck rumbled down the road only a few meters from where we were sitting. I leaned forward, peering into a mug of coffee poured for me by one of her friendly bar workers. Not a single ripple disturbed its smooth surface.

The young barmaid also claimed glasses sometimes shattered in her hands. Lorraine didn't believe her until one particular day, the same thing happened as she put cleaned glasses back behind the bar.

'I went to put it away, and it just burst in my hand!'

Lorraine and her staff could no longer deny something highly unusual was happening.

Lorraine's daughter, Kelly, believes this to be the work of a former landlord, a bit of a ladies' man, frustrated not to be getting any attention from the female bar staff. Kelly also claims to have seen former clientele, from days gone by, still enjoying a drink in the bar area. Bill, sits in the corner, sipping stout, quietly minding his own business and four men, wearing old-fashioned clothing, seen sitting together, are also claimed to frequent the bar. Unlike the glass-breaking former landlord, these are thought to

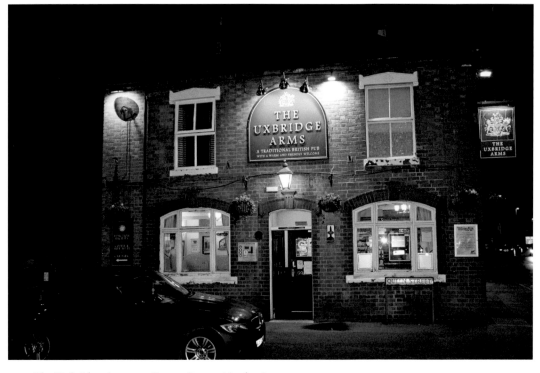

The Uxbridge Arms on Queen Street. (Author)

be residual haunts, oblivious to their modern surroundings; just a moment in time playing back, over and over again. It's thought the same is true of a ghost – never seen but often heard – whistling in the lounge area of the building. Lorraine herself has heard it many times, generally in the mornings or other quiet times, along with a staff member who once looked after the building whilst the owners were away on holiday.

The pub's border collie, Tia, also seems to be aware of something lurking in the building that shouldn't be there. Once, Lorraine was sitting in a chair upstairs when Tia suddenly started barking loudly in her direction. 'She's not actually looking at me; she's looking above me,' recalled Lorraine, who turned her head, expecting to see a 'massive spider' on the wall. Nothing was there. Tia continued barking for at least five minutes before eventually calming down. Tia still often sits for what seems like ages, staring intensely down the hallway. We can only imagine the things dogs can sense that we cannot.

Barton-under-Needwood

Barton Turns Inn

The towpath of the Trent and Mersey Canal is popular with walkers, but if you stop by the Barton Turns Inn for a refreshing drink, you might not be drinking alone. In 1993, Mr John Hickton became the new licensee of the popular canal side boozer and noticed strange goings-on shortly after moving in with his wife and stepson. As with many pub-dwelling ghosts, Sid likes to throw beer mats onto the floor and rattle the glasses behind the bar, but his party trick is to turn pint glasses upside down in front of puzzled onlookers. 'I saw the glasses rocking. Mum had seen the first two go over, and I saw the third one turn,' said Mark, John's stepson.

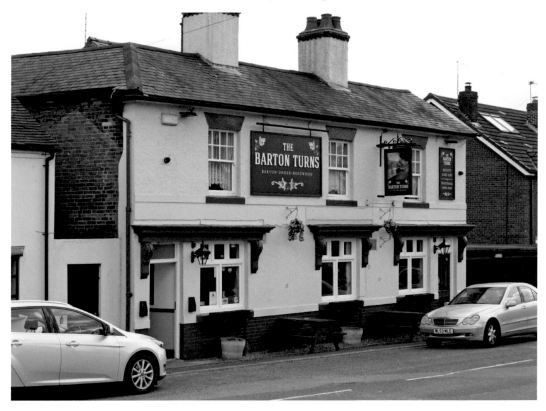

The Barton Turns Inn. (Author)

On other occasions, Mr Hickton would go downstairs in the morning to find windows had seemingly opened themselves, and bedroom doors appeared to open and close upstairs. Footsteps were often heard, noisily running back and forth along the landing, despite no one being upstairs at the time.

John mentioned his experiences to locals, who called the ghost Sid. No one knows for sure who he is, but some have suggested he was a heartbroken farm labourer who hanged himself after being jilted at the altar. However, it could also be an older woman who John saw one day in a rocking chair, gently swaying back and forth by a window, as did a customer when a puff of his cigarette smoke appeared to form around the shape of a woman beside him. The man jumped up and ran out of the building, never to return, although John is far more welcoming of their unexpected guest. 'I know it sounds strange, but I don't want him to go. I don't feel threatened. It may be that he's here to look after things.' If so, Sid should probably be more careful when leaving windows open.

The Barton Turns Inn is a popular place to stop by for refreshments by those using the canal. The 150-km-long Trent and Mersey Canal was built to link the Trent with the River Mersey in the North East, but is now a picturesque waterway used mostly for leisure. (Author)

Branston

One of the more recent ghost sightings in this book occurred in Branston, a village located just south of Burton. On the evening of 10 March 2019, Kim MacBeth and her husband, Mac, were driving through Branston when they encountered an unearthly figure in the road.

'It was about 9 p.m.' Kim told me. 'We were heading down Clays Lane towards Main Street. Not a soul about; we hadn't seen anyone on foot and no car had passed us.' As their car approached the cemetery, they slowed down for a bend in the road when what Kim described as a mist-like anomaly appeared to be crossing the road about 10 to 15 yards in front of them. 'This mist was opaque white, and in the shape of a person; it drifted rather than took obvious steps.' The hazy figure, illuminated by the bright street lamps flanking the road, was thinner nearer the floor, with little definition below where the knees would be.

A mere bump in the middle of Beans Covert woodland is all that remains of the Roman road and settlement today. (Author)

Kim and her husband considered what could have caused a mist to appear, but noted that it wasn't a cold night, nor was there any smoke from nearby chimneys or car exhausts. Confident they had both witnessed something paranormal, they felt honoured, rather than spooked, by what they saw that night.

Kim, a keen local history enthusiast, learned that a Roman road once travelled along a similar route to their misty apparition. This was later confirmed with the use of LiDAR imagery, which revealed the road buried beneath the Beans Covert woodland. Beans Covert, formerly known as Fosters Wood, is believed to be the site of the Roman settlement Ad Trivonam.5 Perhaps one of the former residents still likes to travel along the ancient route into Burton hundreds of years later.

Bretby

This small village, located to the east of Burton, has an interesting and incredibly long history with a settlement in existence since the Anglo-Saxon period. It's likely that the name Bretby, which means 'dwelling place of Britons', was given by the Danes who made nearby Repton their base when they invaded in AD 874.

Bretby Hall

Few buildings in Derbyshire can match the grandeur of Bretby Hall. Hidden out of view by a magnificent country park, the spectacular gardens of the original hall compared favourably with those at the Palace of Versailles. But, despite its tranquil appearance from the outside, the lives of those who once lived there were far less peaceful.

Bretby Hall was the ancestral home of the Earls of Chesterfield, and Philip Stanhope, the 2nd Earl, had more than a few doubts about the loyalty of his young wife, Elizabeth.

In life, Elizabeth Stanhope (née Butler) was said to be a woman of incredible beauty. For her husband, however, it was a marriage of convenience and more of his time was devoted to pursuing a mistress. Feeling neglected, Lady Elizabeth became close with the Duke of York, who would later ascend the throne as King James II. Meanwhile, her husband was convinced that their relationship had become intimate and, when their daughter was born, there were doubts as to who the father was. Eventually, the jealous Earl took Elizabeth to Bretby Hall, intending to keep her there for the rest of her life.

To appease her furious husband, she pledged her innocence under the eyes of God in their private chapel, sipping sacramental wine during the ritual. Soon after the communion, however, she became very sick and was taken to her chamber where she died shortly afterwards, just twenty-five years of age. The Earl maintained to friends and relatives that she was a victim of the 'great plague'[7] but, with nobody near Bretby being affected by the deadly disease, many, including the King, held the opinion that he had poisoned her. The Earl never dared to show his face in London ever again.[8]

Following her death, it is said that her apparition would appear to a bride, but not the bridegroom, laying in her chamber replaying the final moments before her untimely death. After appearing to take a sip from a cup, she utters a loud groan, falls back, and dies. The Bretby Hall she lived in was demolished in 1780, and the ghost of Lady Elizabeth hasn't been seen since.

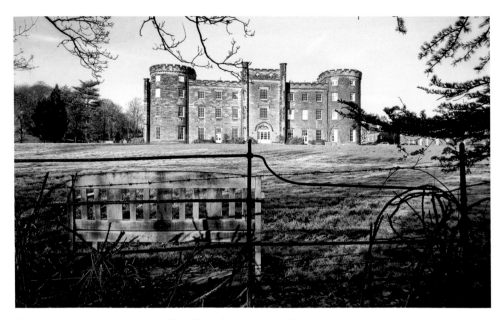

A frosty morning at Bretby Hall. (Photo by James Lafferty)

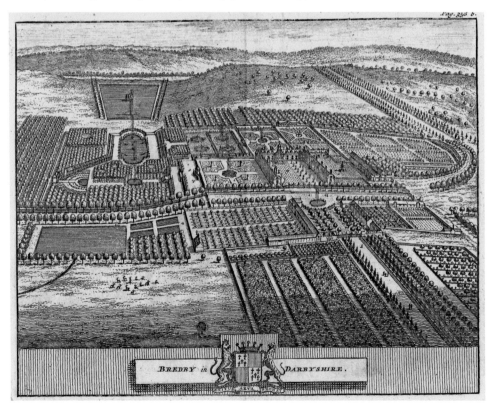

The vast gardens of the original Bretby Hall are captured in a copper engraved print, produced *c.* 1727.

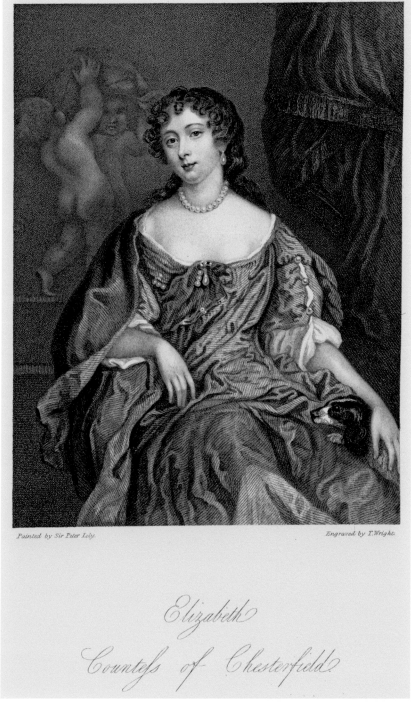

Painted by Sir Peter Lely. Engraved by T. Wright.

Elizabeth

Countess of Chesterfield.

Elizabeth Stanhope (1640–65) was the second wife of the 2nd Earl of Chesterfield but died under suspicious circumstances at Bretby Hall, aged just twenty-five. Engraving by T. Wright from a painting by Peter Lely.

The current hall was built in 1812 in a castellated Gothic style, with circular turrets on each corner of a square block, designed by the same person responsible for the reworking of Windsor Castle. Many changes were made to the hall over time, including parts of the estate being sold off during the First World War, with some of the proceeds used to fund the expedition that led to the discovery of Tutankhamun's tomb by the famous Egyptologist Howard Carter.

Derbyshire Council owned the building in 1927 for use as a hospital, initially as a sanatorium for children before later becoming an orthopaedic centre up until 1997. A few years later, a private developer converted the hall into private apartments, one of which was occupied by Raye Foster, who now lives in Burton. Raye was kind enough to share some of his incredible experiences at the hall, from the early 2000s when the building was still undergoing significant renovation work.

Unusual sounds were common during the eighteen months he lived at Bretby. Metallic noises could often be heard from an adjacent room, formerly an operating theatre, like scissors and scalpels being dropped into trays or on the floor. Once, when shaving in the bathroom, a clear and loud voice next to him said, 'Use an open shaver.' Raye told me that he hadn't ever heard of an open shaver at the time, and had to look it up.

On more than one occasion, several residents awoke to the sound of horses trotting up the lane towards the building, with glass bottles clinking loudly as they drew closer. 'We used to call him the milkman,' Raye told me, believing that this could be the echo of a delivery from a local dairy that once would have been part of a normal daily routine. The sound would pause near the hall, before trotting away and fading into the distance again.

Raye's experiences weren't limited to spooky sounds. On several occasions, he spotted an opaque figure wearing a blue dress with a white pinafore and red belt. The lady, most likely a former nurse, would exit one of the lifts, walk down the corridor before taking a few steps backwards and walking through a wall. The female occupant of that room once fled during the middle of the night after feeling a hand touch her chest.

The most vivid experience for Raye happened outside of the hall when he was walking with his son to a local garden centre. Making their way around the back of the building they saw a boy of around ten or eleven, dressed in old baggy clothes from the Victorian era, appear from a doorway and walk across a courtyard. According to Raye, the boy was so clearly visible that he didn't think it could be a ghost until he vanished into a wall of a newer building that stood in his path. They continued on their original journey and saw the boy again, this time in one of the fields on the grounds of the hall. The mischievous spectre appeared to be playfully running after the horses in the field who were visibly spooked by his presence.

The most recent ghost sightings at Bretby Hall have also taken place outside of the building where, remarkably, at least two unrelated witnesses have similar stories to share. The first was by motorist Lisa Fisher who, in November 2014, reported that she was driving along a lane leading up to the hall at around two o'clock when she saw a lady with black hair dressed in what she described as 'old-fashioned clothes' including a floral dress and a hair net. She was standing with a bicycle that also looked dated and featured a wicker basket. In Lisa's account, she said, 'As I got further down the lane I happened to glance in the rear-view mirror and saw the woman had disappeared.'

This story was published by the *Derby Telegraph*, prompting Janet Fielding, another witness, to share her story which was published in February 2015. In her account, Janet said that she was driving on a different road not far from the hall at around 4 p.m. during heavy rainfall when she too passed a lady in old-fashioned clothes who she described, 'Wearing a floral dress and had her hair in a net. She looked in her early thirties and had black hair. The clothes looked very old fashioned and overall, she looked out of place.'

I asked Raye about the lady with the bike during our conversation. He saw her three or four times during the early 2000s too, usually in the early evening. Many others at the time mentioned seeing a lady with a bike on the lanes around the hall; one motorist was even convinced that he had driven into the lady only to find no sign of her when getting out of the car to check.

Strangely, despite having a high level of paranormal activity in the past, ghostly sightings are no longer a common occurrence at Bretby Hall today. The reason for the subsidence of activity, we'll never know. Perhaps they've simply faded away with time.

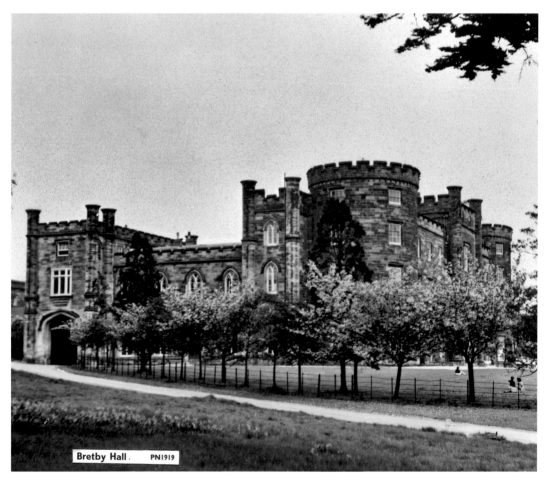

Bretby Hall was a popular subject for postcards in the early 1900s. (Courtesy of the Charles Webster Collection)

A lady dressed in old-fashioned clothing, standing with a bicycle, has been seen several times on the lane leading up to Bretby Hall. (Photo by James Lafferty)

Bretby Business Park

The heavy rain poured relentlessly throughout the night, making this an unpleasant shift for the security guards at Bretby Business Park. It was the middle of winter, and the torrential conditions made it seem even bleaker outside than normal for this time of year. The sight of a figure emerging from the darkness was completely unexpected for one of the security guards. It was a young lady wearing a pretty summer dress, completely unsuitable for the current conditions. She approached the guard and told him that she was lost and needed directions to nearby Stapenhill.

After their brief conversation, the young lady left, leaving the guard bewildered by her appearance. 'Who was she? Why was she walking around at night in the summer dress? Was it just a dream?' When the CCTV footage of the night was checked, the guard was horrified to see only himself – appearing to speak and gesture to an empty space – with no sign of the mysterious young lady in the dress. Could this have been the same young woman seen along the roads near the hall?

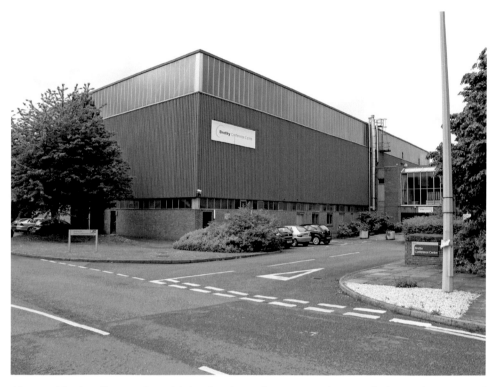

Along with the disappearing girl in the dress, former security guards have also reported seeing car headlights approaching along an exit road out of the business park before suddenly vanishing before reaching the gatehouse. (Courtesy of Simon Deacon)

Brizlincote Hall

Built by Philip Stanhope, 2nd Earl of Chesterfield, as a permanent home for his son, Brizlincote Hall is a beautiful seventeenth-century manor house in the parish of Bretby. Legend says, the Earl built the hall for his French mistress, complete with an underground passage linking it with Bretby Hall for discreet meetings. This is, of course, a complete myth – the seventy-two-year-old Earl died before the hall was completed. Conspiracies aside, Brizlincote Hall's strange design was influenced by a French chateau owned by the Earl, and in his *Shell Guide to Derbyshire* (1972), Henry Thorold described it as, 'Perhaps the finest small baroque house in England.'

Locals long insisted that the mansion was haunted, and in June 1922, tales of Brizlincote's ghosts travelled as far as Canada, when Ontario's *The Expositor* published an account by a Miss Walker, who lived in the hall with her father. She said that on wild and stormy nights, 'A ghost glides through the creaking corridors and rooms of the old mansion.'

In an interview with the *Birmingham Gazette* in the same year, she elaborated on her experiences. One particular night, Miss Walker had been lying awake for some time – uncomfortable in her bed – when she heard a creaking floorboard nearby. Looking up, she saw a tall figure in white, standing at the window.

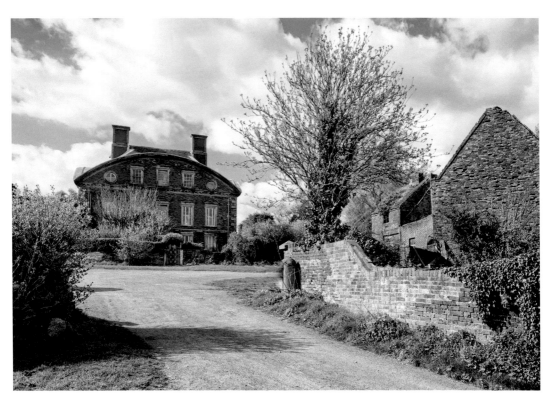

Brizlincote Hall, from the finest baroque house in England to a functional farmhouse. (Photo by James Lafferty)

'I tried to speak,' she said, but, petrified, was dumbstruck. On another occasion, she saw the ghost pass across the foot of her bed. Horrified, she closed her eyes but couldn't shake the feeling of a presence still lurking in her room. Miss Walker said she had never believed in ghosts, but that had now changed.

Later occupiers of Brizlincote Hall dismissed any claims about it being haunted, including the Startin Family – living at the hall in the 1930s – who said rumours were fuelled by silly stories taken out of context. One particular night, Mr George Startin and his family headed out for an evening Whist Drive, leaving their home in the hands of their fifteen-year-old son. He was sat quietly reading in his room when he heard footsteps thudding down the steps of a staircase leading to the attic. Bravely, he grabbed a nearby torch and went to investigate, finding no trace of anything amiss. Later, he heard the same noise but again found no one. Determined to get to the bottom of things, he sat alone in the darkness at the bottom of the steps. Once again, out of the empty shadows, the now familiar thudding sound began to make its way down each step and as the boy shone his torch towards it, he saw an apple bouncing towards him. He ascended the stairs to find rats had gnawed through an apple crate; a few had fallen out and rolled down the stairs.

Any chance of spirits continuing to haunt the house in later decades was quashed in 1984, when Doris Lomas – whose family lived in the hall for three generations – said she had yet to meet a ghost for herself during that time, 'Though I certainly wouldn't mind doing so,' she added.

So, what happened to the 1920s ghosts? Shortly after Miss Walker's stories appeared in various local – and international – newspapers, *The Burton Observer* shared an official statement from 'The National Union of Ghost Layers'. The document was essentially a written order issued to ghosts, following an increasing tendency 'to indulge in unauthorised haunting of premises'.

The statement read, 'That legitimate haunting only be permitted between the hours of 12 p.m. and 3 a.m., December 24th-25th,' and 'That no ghost shall creek, trump, groan or rattle chains to the annoyance of lawful tenants,' amongst several other restrictions.

Whether this document was issued seriously or as a joke, it seems to have done the trick.

Brizlincote Hall later became a working farmhouse and is surrounded by many acres of picturesque meadows and pastures. (Author)

Church Gresley

Just a few miles south of Burton is the village of Church Gresley, whose origins date back to the twelfth century when Gresley Priory, a monastery of Augustinian canons, was founded there. After the Dissolution of the Monasteries in 1536, the town became a home for local coal miners and potteries including the world-famous TG Green & Co., makers of the blue and white Cornishware.

Gresley Old Hall

On a cold February night in 2006, I was making my way to Gresley Old Hall, unaware that this night would forever determine my beliefs in ghosts. On arrival, I joined my fellow Swadlincote Paranormal Team members in one of the ground-floor function rooms, busily preparing to host a small event for a local charity. At the time, ghost hunts and similar events were a relatively new thing for Gresley Old Hall, but

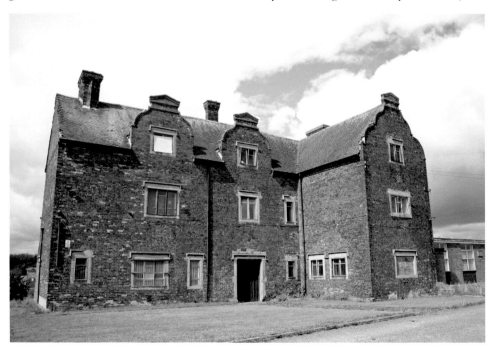

Gresley Old Hall, 2020. (Author)

over the following years, it gained a reputation as a rich hive of paranormal activity, making it incredibly popular with ghost hunt organisers and the thrill-seekers who join them from all over the UK. Many who visit report hearing footsteps and dragging noises, whilst light anomalies and shadowy figures have been seen in various rooms on the upper floors. Others say they have been touched or made to feel unwell by the spectres that haunt the hall.

We set up our projector screen and positioned a handful of chairs around a large fireplace, the only remnant of the original hall, built in the 1500s by Sir Christopher Alleyne, allowing him to be closer to his new wife after marrying into the influential Paget family. The current hall was built in 1664, using clay excavated from the surrounding grounds to make its red bricks; many extensions and alterations have since been made. However, it wasn't always a family home, serving at times as a farmhouse and even a pottery factory, before becoming a base for the South Derbyshire Miners Welfare Club.

Ghost hunting events can be good fun, but crowds of anxious people shuffling around dusty rooms isn't a good environment for any serious investigation work. A couple of hours before any guests were due to arrive, I decided to set up a camera that could be left locked away and undisturbed on the spooky upper floors of the building. Another investigator, a fellow sceptic named Vince, agreed to come along to give me a hand. We spiralled our way up the stairs, with a maroon carpet underfoot and varnished oak bannisters creating a warm, homely ambience. On the third floor, our progress was blocked by a white wooden hatch, secured shut with a padlock. It was sealed for a good reason, as beyond this threshold, the derelict part of the building awaits. We removed the padlock and cautiously made our way through.

The date stone above the doorway was taken from the original Gresley Hall, and is now heavily weathered after almost 500 years of wind, rain and sunlight. (Author)

It's already been many decades since the hall was last used as a family home, but it is still able to provide shelter for some of Church Gresley's avian residents. (Author)

The staircase continued its ascent, but in surroundings that felt otherworldly. We entered a cold, dark place, like travelling in a different dimension, void of colour. The carpet was non-existent, and the bannisters, worn bare of their varnish, were instead covered by a thick layer of dust. The walls were in an equally poor state, with most of the paint flaking away, replaced by patches of mould and dampness. The ceiling above us was scattered with holes where the plaster had crumbled away, with cobwebs draping the cavities left behind. We made our way further into the abyss, taking tentative steps along the staircase that was parting from the wall, with only a few joists desperately clinging on.

Reaching the top of the stairs, a rickety old door stood in front of us with a chalk inscription that read, 'Danger, Keep Out - 1982'. I decided to heed the advice and refrained from entering, but felt this would be a good place to set up my camera. I grabbed a nearby chair, placed the camera on its seat, and positioned it to face through the doorway into the room beyond. As per my regular routine, I turned the camera on with night-vision mode active, using the side-attached viewfinder to align the lens before starting the recording. As the viewfinder flipped open, I saw the face of a young lady, possibly late twenties or early thirties, who appeared to be a couple of metres away from the camera.

She was visible with complete clarity; I could see every detail of her face, along with her light-coloured hair, combed straight to a length just below her cheekbone. My initial thought was I had accidentally left a tape from a previous event in the camera, and it was playing back some footage of one of our guests during a vigil, especially as she appeared to be at a strange angle, with only her head – from the middle of the neck upwards – visible within the frame of the screen.

Making our way through the hatch into the decaying upper floors of Gresley Old Hall. (Author)

Without thinking or saying anything, I instinctively picked up the camera to switch the tapes over, when I noticed the face on the small screen had moved out of shot. I realised that what I could see through the viewfinder was not footage being played back, but the doorway right in front of us. Still silent, but now in disbelief, I moved the camera back to its previous position, but by now the face had vanished. I panned the camera around the doorway for a few seconds, searching for her in vain before Vince, standing behind me and looking over my shoulder, asked, 'Did you just see a face?'

As much of a sceptic as I may be, this experience is one that I firmly believe was a rare, true ghost sighting, and one which has fuelled my continued interest in the subject of the paranormal ever since. The face was far too clear to be an illusion or caused by a lighting anomaly; it was witnessed by a second person, so I know I didn't imagine it, and it wasn't caused by the power of suggestion, as I knew what I saw before Vince mentioned it.

I have returned to Gresley Old Hall many times since, always positioning a camera in the same spot, but I never saw her again. Since then, I have often wondered about the identity of this apparition. Could it be one of the many people who lived in the hall at some time during the last few hundred years? Could it be one of their servants or maids? Of course, I will never be able to do anything other than speculate, but the experience will stay with me forever, reinforcing my opinion that Gresley Old Hall is one of the most haunted buildings in the Burton area.

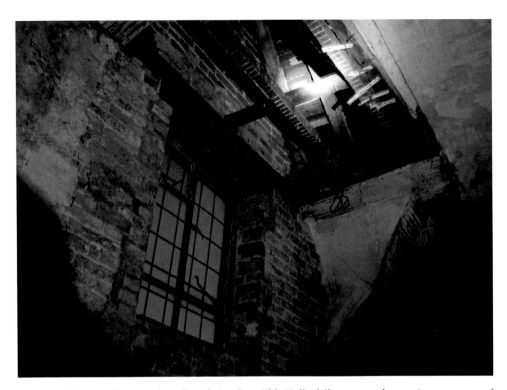

The crumbling ceilings and walls of Gresley Old Hall, falling ever deeper into a state of dereliction. (Author)

The doorway where I witnessed the apparition of a young lady, taken by the author during a later visit in February 2010. (Author)

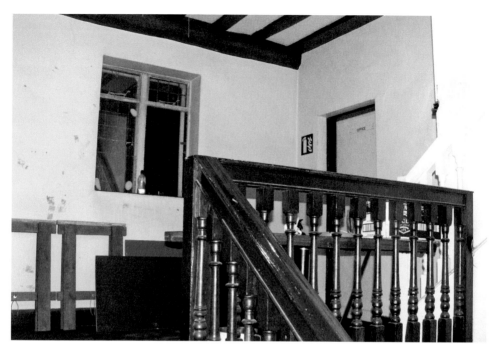

The floor below the derelict rooms of Gresley Old Hall. To the right of the image, a white-painted banister leads to the abandoned upper floors, locked away behind a wooden hatch. A wooden wall behind the white banister was built to separate the two areas. (Photo by Stephen Griffiths)

One of the upper-floor rooms of Gresley Old Hall in 2006. (Photo by Stephen Griffiths)

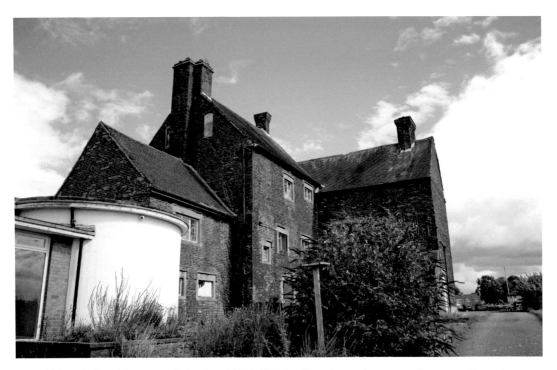

Although the oldest part of Gresley Old Hall is derelict, the modern extensions are still used as an important venue for the local community.

Ghost in the Attic

Originally built for workers from the once-thriving nearby collieries and potteries, the Old Hall is now surrounded by residential housing. Ghost sightings are prevalent in the area, with a report in the *Derby Telegraph* suggesting that Regent Street is South Derbyshire's most haunted (17 May 2020). One of the most fascinating stories is that of Dawn and Kevin Warren, who have lived in their Church Gresley home for over twenty years. The intensity of paranormal activity reported by the family was so great that their story was featured on an episode of *Living with the Dead*, aired on Living TV in the UK in 2008 (season 1, episode 3). As with so many other ghost stories, this one began when the couple decided it was time to start renovating their ageing home.

Dawn was the first to encounter unusual experiences. One night, she suddenly awakened, to see what appeared to be a girl, wearing a long white nightdress, standing by the bottom of her bed. At first, Dawn put this experience down to imagination and tiredness and thought little more of it. Uncannily, a few years later she saw the same girl in the downstairs living room. Over time, the frequency of spooky activity in their terraced household began to gradually increase, with lights going on and off and the sound of footsteps being heard by all family members.

Dawn's husband, Kevin, also believes he saw the same girl in the white dress witnessed by his wife. On another more frightening occasion, he opened the door to their pantry to find an older woman sitting inside. She did not move or react to his presence, just stared at him with a sinister gaze.

The family were not overly concerned at the prospect of sharing their home with the gentle ghost of the girl in the white dress, but as time went on, they felt darker presences coming forward more often, and in 2007 they called upon the Swadlincote Paranormal Team to try and get to the bottom of the spooky goings-on.

During our initial visit, Mr Warren showed us something in the attic space the family considered highly unusual. Upon climbing the ladders and peering through the narrow loft hatch, we saw a dusty antique nursing chair standing alone in a corner. The origins of this chair were a complete mystery to the family; no one knew why it was there or even how it came to be in this tiny space – the chair was far too large to fit through the small access hatch. The family used the loft to store and fetch Christmas decorations, describing how the chair changed position periodically, even finding it lying on its side, only to right itself later.

We suspected that the mysterious old chair might be linked with the spirits who appeared to the family, possibly former users held back by its presence. Several months after the team's initial visit, the *Living with the Dead* film crew decided that the chair should be removed from the family home. Workers had to cut away beams in the ceiling to make the loft hatch large enough for the chair to pass through, before being lowered out of the loft for the first time in many decades. Whilst the show's medium, Ian Lawman, performed a ritual to remove the spirits, the dusty old chair was carted outside to be burned. Over the course of the following weeks, the family reported the hauntings had stopped, and they were finally able to redecorate their house.

The spooky chair in the attic – photo taken in 2007 during the initial investigation by Swadlincote Paranormal Investigations. (Photo by Stephen Griffiths)

Investigator Simon Deacon squeezes through the narrow hatch to see the chair for himself. (Photo by Stephen Griffiths)

Stephen brushed the chair with his fingertips to reveal a strange ornate pattern on the backrest. Unfortunately, we couldn't trace this design back to a manufacturer or date. (Photo by Stephen Griffiths)

Is Regent Street the most haunted road in South Derbyshire? (Author)

Drakelow

For over fifty years, the skyline around Burton was dominated by the enormous, conical-shaped cooling towers of Drakelow Power Station, finally demolished in 2006 – an unforgettable sight for the hundreds, who alongside me, watched from the Trent Bridge, as with an almighty boom, the towers crashed to the ground.

The power station stood on the site of Drakelow Hall, a stunning country house and the ancestral home to twenty-eight generations of the Gresley family. Few traces of this majestic building remain today, with only the crumbling steps of a sunken garden now visible from the golf course on the opposite side of the river. To view the hall's breathtaking landscape Fresco – painted in 1793 – which once stretched across all four walls of its dining hall, you'll have to travel to the Victoria and Albert Museum in London.

However, the history of Drakelow begins much earlier during the time of the Norse Vikings, with the earliest mention – *Draclaw Hlawe*, meaning 'Dragon's Mound' – dated AD 942 (in a grant of land made by King Edmund I). The village of Drakelow existed for only a few short centuries before being abandoned when, sometime around 1090, all its residents fled in the most unusual circumstances.

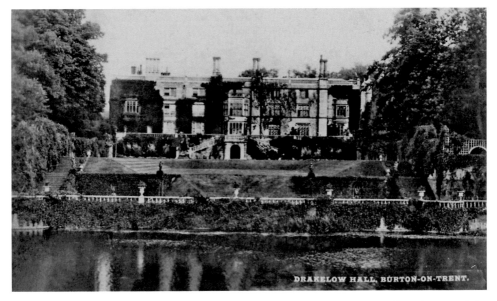

The magnificent Drakelow Hall in the early 1900s. Only the crumbling walls and steps of the sunken garden are visible today. Picture taken from a postcard posted in 1917.

The Revenants of Drakelow

As dusk began to steal away the light of the day, the people of Drakelow sat down to their evening meals unaware that terrible events were about to unfold. In the distance, staggering clumsily towards the sleepy little hamlet, the unmistakable shapes of two men came into view. With each laboured step their appearance grew more familiar and more horrifying; the two men had been buried deep within the earth that same morning. Sure enough, the undead beings were soon wandering the village streets, stopping only to bang their coffins against the doors and walls of its houses. 'Move, quickly, move!' they barked. 'Get going!'. Their relentless onslaught continued until sunrise when they seemingly returned to their graves.

A few days earlier, the same two men fled nearby Stapenhill – where they laboured under the rule of the Abbot of Burton – to Drakelow, part of lands owned by the Norman aristocrat Roger the Poitevin. Hearing that their crops had been seized by their former monastic overlords, they went to Roger, accusing the monks of serious wrongdoing against him. By the time it was known that these accusations were false, it was too late. In his rage, Roger had already assembled a force of sixty knights and peasants to punish the monks by force, and raid their crop stores in retaliation.

As Roger's small army descended upon the crop fields, the abbot knew his ten knights would be no match for them. He ordered his men to stand down and rushed to St Modwenna's shrine in the abbey to pray for a miracle. While the monks knelt inside the abbey, the knights – watching their enemy lay waste to their crops – could no longer bear this injustice. Ignoring their orders, the small troop bravely took up arms against the intruders, despite believing defeat was inevitable. Miraculously, their defence was so fierce that the ten men were able to drive away their opponents, who fled in shame. The monks' prayers had been answered, and those responsible for the needless battle would face the wrath of St Modwen.

The next day, the two wicked peasants, unaware of the bloodshed and mayhem they had caused, sat down to eat their afternoon meal, only to be struck down by sudden and unexplained death. They were buried in wooden coffins in Stapenhill the following morning but, as the events of that evening proved, were unwilling to remain in their graves.

Each night as darkness fell, so too returned the undead peasants and with them came an epidemic that killed most of Drakelow's residents. Count Roger, realising his error, went to the abbot to beg for his pardon and return double what was taken, but the sickness continued to spread leaving only two survivors, bed bound with sickness, in the hamlet. Out of desperation, the bodies of the peasants were exhumed, their heads removed and placed between their legs, and their hearts ripped from their bodies. On Dodefredesford hill, their hearts were cast into a fire that burned from sunset to sunrise; when, following a loud crack, the image of a black crow – an evil spirit – rose from the flames and disappeared into the sky.

The two remaining residents, laid out in their beds with illness, suddenly became well as smoke from the fire filled the distant skyline. Gathering all their possessions they fled, leaving the hamlet of Drakelow abandoned forever.[9]

Hanbury

RAF Fauld

Just a fifteen-minute drive along the A511 towards Tutbury lies the village of Hanbury. Many people won't have heard of this small and peaceful village, but it played a significant role during the Second World War.

Old Gypsum mines had been secretly converted into a large munitions store in a huge network of tunnels, deep underground, safe from aerial attacks. Unfortunately, however, at 11:11 a.m. on 27 November 1944, a worker made the fatal mistake of using a brass chisel to remove a detonator, creating a spark that ignited one of the bombs. The error set off a chain reaction that would lead to between 3,500 and 4,000 tonnes of explosives detonating in one terrible explosion. The blast threw over a million tonnes of rock and soil into the air, which rained down on the surrounding villages and fields, destroying many buildings and bursting a nearby reservoir.

Fauld Crater in 2020. Since the tragedy, nature has done its best to hide the crater it left behind. A walk around it is the best way to appreciate its size. (Author)

A farmhouse once stood directly above the blast area, but no trace of this building or its unfortunate occupants was ever found. Around 200 cattle and seventy people were killed in this tragic event, with eighteen of the bodies never being recovered. Following the disaster, one search party reported coming across a cow standing motionless in a field. The poor beast was twice its normal size, inflated by air under great pressure. The cow was shot by the search party to avoid further suffering, but it didn't fall down. It was already dead, propped upright by its legs.

It was one of the largest non-nuclear explosions ever to have happened, with seismographs as far away as Rome able to detect its shockwave. Many buildings in the surrounding area were severely damaged, including in Burton where the spire of Christ Church was cracked so extensively it had to be demolished.[10] Anyone from Burton who heard the blast and looked outside would have seen the billowing column of smoke rising thousands of feet into the sky. Nowadays, a crater over 100 feet deep and three-quarters of a mile long scars the land, although the risk of unexploded bombs means only the rim of the crater is accessible by foot.

Access to the surviving tunnels and chambers have been sealed off for obvious safety reasons, but some visitors to the site report being overcome by feelings of utter grief and intense feeling of sorrow. Others have reported hearing crying and sobbing seemingly coming from underground, along with disembodied voices that eerily hang in the air around them.

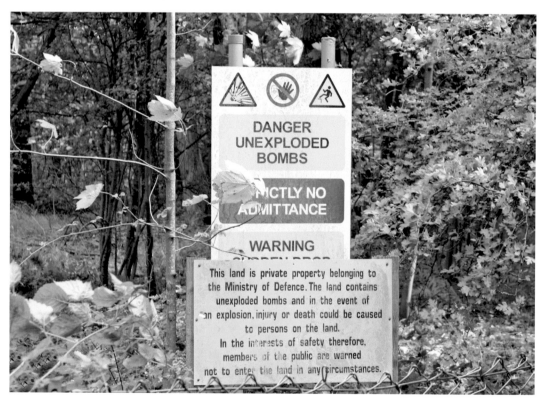

The area is now sealed off to the public due to the risks of unexploded munitions and to prevent illegal access to the remaining tunnels around the facility. A footpath has been laid around half of the crater's rim for those who wish to see it for themselves. (Author)

A memorial stone was unveiled in 1990 to remember those who lost their lives in the disaster. The Sicilian marble stone was donated by the Italian government and flown to the UK on an RAF plane. (Author)

The Cock Inn

For most people who take a trip to see the crater, The Cock Inn is where their walk will either start or end. Not only is it just half a mile away from the site of the disaster, but visitors can also enjoy sweeping views across the Dove Valley whilst enjoying a refreshing drink or two.

The Cock Inn was built in 1950 after the original pub was, not surprisingly, severely damaged by the Fauld explosion. Unfortunately, the builders mistakenly switched the plans with those for another project the brewery was undertaking at the time, so somewhere in Birmingham is a quaint village pub whilst Hanbury now has a more austere – slightly out of place – looking building for its local. Fortunately, the great atmosphere inside from the friendly staff and locals more than makes up for it.

Penny Neale, a staff member at The Cock Inn, was kind enough to share some of her unusual experiences with me. On a typically dark winter morning in 2021, Penny

arrived early for some cleaning duties before opening the doors to visitors for the day. It was around seven in the morning, and the only other person in the building was a tenant who lived on the first floor and typically didn't leave until around ten o'clock, so Penny started with a few of the quieter tasks. Near the bar area is a window, through which a passageway joining the two main areas of the pub can be seen. While Penny was bending down to clean an open fireplace, she heard a noise and looked up to see a young boy with blonde hair, aged around five or six, running on the other side of the window. Maybe the chef arrived early, Penny thought, and some relatives or friends and their children had tagged along. She opened the door to the passageway and, in a welcoming tone, called out 'hello', but there was no response. Penny walked through the corridor, into the next room and back again, calling out all the while. It quickly became evident that she was the only person there. Penny thought the experience was strange, but didn't let it bother her too much at the time. Later, she was wiping down tabletops in the bar area and, as a habit, would stack the square cardboard coasters in the centre of the table. She left the room for a moment, only to find them returned to the corner of the tables again when she returned.

On other occasions, she has heard quiet voices whispering and laughing, whilst the tenant upstairs said they could sometimes hear barstools moving on the floor in the middle of the night. Fortunately, Penny feels the presence is friendly, playful, and certainly nothing sinister. Perhaps they are naturally drawn to the joyous atmosphere enjoyed at the pub today.

The Cock Inn, Hanbury. The plans were accidentally swapped with those for a pub to be built in Birmingham when it was rebuilt after the Fauld explosion. (Author)

The Cock Inn boasts stunning views of the Dove Valley, to which the camera doesn't do justice. (Author)

Newton Solney

Newton Park Hotel

At the end of a long day, Pamela Chester and her friend were looking forward to a well-earned sleep. It was 1973, and the two girls were spending some of their school holidays working at Newton Park Hotel, serving in the kitchens and helping out the other chambermaids where needed. Buses stopped running in the evening and it was a very long walk home, so the hotel kindly offered the girls one of their vacant twin-bed rooms. Exhausted, they climbed into their comfy beds and quickly drifted off to sleep.

Unfortunately, Pamela's sleep was disturbed when she heard her friend walking around the room. She's probably going to the toilet, Pamela thought, so just ignored it. The sound of footsteps continued, and Pamela felt the weight of her friend sitting on the end of the bed, before getting up and walking around some more. That was enough for Pamela, who quickly sat upright and switched on the light to ask her friend what on earth she was up to, only to find her fast asleep in the other bed. Pamela left the light on and didn't go back to sleep that night.

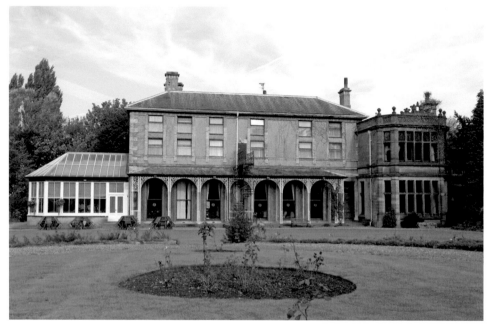

Newton Park Hotel – photo taken from the rear garden. (Courtesy of Simon Deacon)

The morning after her sleepless night and still shaken by the experience, Pamela told her older sister, who was working on reception at the time, about what happened. She didn't pay much attention to her story and dismissed it. A few days later, another guest staying in the same room ran downstairs and spoke to her in a flustered state. This guest's night was also ruined when she was awoken suddenly in the middle of the night by the radio playing loudly. In the morning, she left her room for a few moments only to find on returning, her towels and sheets scattered around the bedroom and bathroom floor.

The hotel was built in 1759 as a home for a local businessman, Abraham Hoskins, who wanted somewhere to enjoy his later years in life. It was designed in the style of an Italian mansion by Francis Bernasconi who also worked on Windsor Castle and Buckingham Palace. Abraham's son built Bladon Castle on a nearby hillside, although in reality, it was nothing more than a long brick wall designed to look like a grand castle overlooking the family home. The locals, suffering in a time of financial hardship, were so outraged by this extravagance that the Hoskins hurriedly built rooms behind the wall and ended up living there, claiming this was always the purpose of the castle. Spiralling costs forced the Hoskins to sell Newton Hall in 1836 to Burton brewer William Worthington, who made alterations that brought the building up to the one we see today. It was then owned by the Ratcliffe family, another famous brewer, from 1879 until 1955 before opening as a hotel in 1966.

One of the surprising things about Newton Park Hotel is that despite there being no history of murders, suicides and other tragedies normally associated with hauntings, it has many spooky stories to tell.

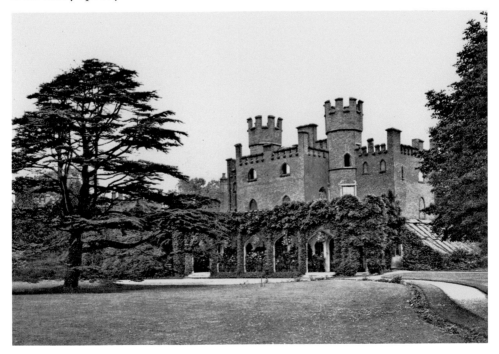

Originally a folly overlooking the River Trent, Bladon Castle was hastily converted to a country home to appease locals, furious at its owner's extravagance. (Picture from 'Boots Fine Art Views of Burton', supplied by Ian Webster)

In 2006, during a Swadlincote Paranormal Team investigation, a chef disclosed an unusual experience in the kitchen area. He was working late one night and when, after stepping outside for a few moments, he returned to the kitchen, was startled to find that the room was filled with steam. Hot water was gushing at high speed from a tap, yet there was no one around who could have turned it on. Another chef mentioned that when he was working, he would often see movement out of the corner of his eye, only to look up and find no sign of anyone else around. In a separate incident, staff were forced to break into a disused outhouse after guests commented that the word 'help' appeared to have been written onto the inside of the window. Nobody had access to the room behind the window as this part of the building had been out of use for thirty years.

Other staff reported hearing what sounded like a small child playing in the maze of corridors and tunnels within the basement. It is thought that this could be the echo of a boy playing hide and seek many years ago, in a forbidden part of the house. As in Pamela's case, guests have also reported some unusual experiences. Some were woken in the middle of the night by a knock at their door, behind which stood a maid in old-fashioned clothing, holding bed linen, who suddenly vanished. In another room, a lady was reportedly seen and heard weeping at the foot of the bed before too vanishing.

Narrow tunnels stretch out underneath the gardens, possibly used for pipes to power an old fountain. The ghost of a young boy reputedly haunts these hidden passageways in an eternal game of hide and seek. (Courtesy of Simon Deacon)

The diverse accounts of hauntings have made Newton Park Hotel popular with paranormal enthusiasts, with several public ghost nights taking place over the years. On one of these occasions in late 2006, a bright light – like a streak of lightning – was seen in the basement by several people simultaneously, whilst others saw shadowy figures in other parts of the building.

With such a high number of experiences, it is almost certain that Newton Park Hotel will continue to spook its visitors for many years to come. What is less certain, is why it's so haunted in the first place.

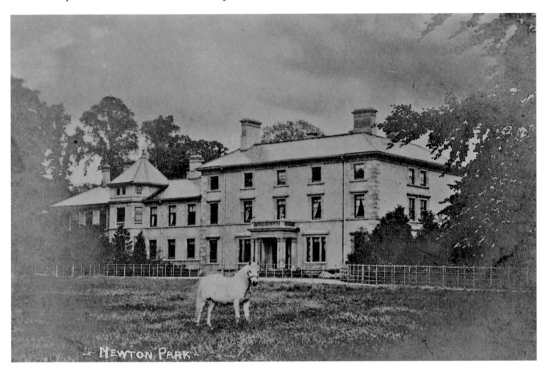

Newton Park Hall was a country house enjoyed by several of Burton's influential and wealthy families. The attractive structure was an ideal subject for postcards, such as this one from around 1904.

Stapenhill

The Viaduct

The setting sun signalled the end of another day for Anthony and his friends: five schoolboys enjoying the long summer holidays, filled with activities. Earlier, they had cycled out to Branston Bridge – trainspotting – and having waited for the 8.30 p.m. southbound mail train to pass, agreed it was time to head home. As the locomotive steamed away into the distance and out of sight, daylight rapidly faded.

Normally, it would be a short ride home, but on this occasion, a punctured tyre meant the boys would be walking. They scrambled up the Branston road bridge embankment to begin their walk along the train tracks towards Stapenhill. It was 1974, and still in the age of steam; the boys were less aware of the dangers of walking the tracks than they are now as adults.

The viaduct crossing the Trent from Stapenhill into Burton. The pillbox in the centre was one of several installed during the Second World War to defend against an invasion of Britain.

Soon they were approaching the viaduct – a long string of stone arches – crossing over the River Trent. By now, it was dark and the air around them had grown chilly. The lads were walking in two groups, with two in front whilst the other three, including Anthony, followed close behind.

Anthony recalls chatting enthusiastically about the trains they had spotted, when suddenly the leading pair came to a halt. Unsighted by the surrounding darkness, the following pack walked straight into the backs of the stationary boys. 'What yer bloody stopped for?' they exclaimed. There was no response. The two boys out front froze, staring ahead as if petrified. Anthony and the other two, frightened by the silence, peered into the night, to see something unexpected and otherworldly in their path.

'It was like an illuminated mist in the shape of a human figure.' Anthony told me. There were no facial features, but the shape of a head and shoulders was unmistakably human. The pale glowing figure stood very tall, but the legs only seemed to go down to the knees before fading away completely. The boys stared, transfixed, trying to make sense of the shape that had appeared in front of them, when, to their horror, it began to move towards them.

'It didn't walk as such,' Anthony said. 'More of a gliding movement.' Either way, it was enough to send all five boys sprinting back the way they came. Horrified, they didn't stop until they reached Branston road bridge several hundred metres away, where the streetlights below gave them some sense of safety.

'We just stood there shivering,' Anthony recalled. 'It affected us all quite badly; one of us was openly sobbing.' After the event that particular boy stopped going out with them. In the end, they were happy to go the long way home.

In the following days, hoping for answers, the boys told others what they had seen. They learned that the bridge was associated with several deaths, including workmen who died constructing the railway line, victims of drowning nearby and even suicides. Their sighting sparked such an interest from family and friends, that exactly one year to the day later, over seventy people gathered in the evening by the bridge, hoping for a glimpse of the apparition.

Anthony's sketch, illustrating the spooky encounter in 1974. (© Anthony Gregory)

The bridge is a quiet and beautiful place to visit, although Anthony could be forgiven for feeling uncomfortable about returning. (Author)

Unfortunately, no spooky figure appeared that night, nor has there ever been a sighting in the many years since. Despite this no-show, the feeling of dread surrounding the bridge was so strong that eventually a local religious man took it upon himself to exorcise the bridge and put its spirits to rest.

Stapenhill Cemetery

During our conversation, Anthony told me of another spooky experience he had in Stapenhill. It was 1981, and Anthony, now aged nineteen, had been enjoying a night out with his friend Brian in one of Burton's many nightclubs. Eventually, closing time was upon them, and it was time to head home, but they'd left themselves a bit short and couldn't afford a taxi. Instead, they decided it would be a nice night to walk home. Along their route, Anthony spotted a shortcut. 'Let's go through the cemetery,' he said to his friend. Brian agreed, and the two young men started walking along the central path towards Elms Road.

As they neared a crossroad in the middle of the cemetery, they saw what appeared to be a figure lying down on the path. Whilst there were no discernible features, it had the distinct shape of a head and shoulders that seemed to almost glow out of the darkness around them. At first, Anthony thought he must have had way too much to drink, but then his friend Brian said, 'What the hell is that? Can you see it as well?'. Anthony confessed that at this point, he would have run in the opposite direction, but, with the help of some Dutch courage, he walked quickly towards it. The closer they got to the strange shape in the path, the more it faded away before disappearing completely, leaving them feeling suddenly more sober.

Stapenhill Post Office

For anyone driving into Burton via the A444, it's hard not to notice the Stapenhill Post Office. The predominantly white frontage decorated with a black balcony and window frames stands out like the proverbial sore thumb against the more modern red-brick building next to it. Another peculiar thing about this unique-looking post office is that it's unclear whether it is haunted by one ghost, two ghosts or none whatsoever.

The question was first posed in a *Burton Mail* article published in September 1986. At the time, the post office had recently been taken over by John and Joyce Adams, who, only a day after moving in, were approached by Mr Bailey, a former proprietor. 'Have you seen the ghost yet?' he asked them. They had not and gave little more thought to it until seven years later when they were visited by Alan Shotton, who told them that he spent many of his childhood years at the post office when his great-uncle owned it in the early 1900s. He told the Adams' that a ghost was sometimes seen walking from the rear of the building – where a chapel once stood – through a wide door nicknamed the coffin door, now bricked up. The Adams' had been in the post office for seven years, and they still hadn't seen this ghost for themselves, although creaking floorboards made them wonder if an unseen presence still lurked.

A few days after the feature, Mrs Twigg, the daughter of a former postmaster, contacted the newspaper with her own experiences. She, too, heard about a ghost nicknamed the 'Blue Lady' who had allegedly been seen several times since the Shotton-Bailey family moved into the building in 1879–80. This blue ghost, too, walked from a pear tree in the garden to the old coffin door.

Stapenhill Post Office. (Author)

However, Mrs Twigg's experiences involved hearing strange noises and thuds from the attic rooms – at one time bedrooms – that led her to believe a second spirit could reside in the building. She recalled how family members would avoid using the landing area between the two front bedrooms as it always felt a little strange, especially near the stairs leading up to the attic rooms. The family cat also avoided this area, as did the Adams' four dogs. They described a previous dog howling with terror when carried upstairs, desperately breaking free and running back downstairs. As a young girl, Mrs Twigg and her mother went downstairs once to find the living room looking like it had been ransacked with books and papers spread all over the place and an easel broken on the floor. Whilst the Adams' haven't suffered to the same extent, they had noticed an inexplicable draught in the living room despite fitting double glazing and keeping doors closed.

If the Stapenhill Post Office does have two ghosts, neither of them were frequent enough visitors to trouble Mr and Mrs Adams, but what will future postmasters see and hear?

Tatenhill

The Horse Rider

As he calmly drove, Mike Hamilton and his wife were chatting about their evening's outing. They were heading home after visiting his mother in Barton-under-Needwood, taking the scenic route through the ancient village of Tatenhill. It was around nine in the evening, sometime during the late 1960s, and a faint mist hung over the fields and low-lying areas in the cool October air.

Soon after passing the thirteenth-century sandstone church, they reached a dip in the road that's flanked by a steep grass bank, before winding away through farmland and meadows towards Henhurst Hill. As the car descended the little slope, Mike distinctly saw the dark misty figure of a rider on horseback appear to go over the top of the car as they drove. The rider looked like he was from a much older time, dressed in a long dark cloak with a broad-brimmed hat. Mike turned to his wife and asked if she saw anything, to which she also described seeing a highwayman-like figure on horseback above them.

Eventually, the intrigued couple stopped the car, turned back and drove the same route through Tatenhill again thinking it may have just been a trick of the light. Only this time, they saw nothing.

A Ball of Fog

In June 1985, many years after Mike Hamilton's sighting, Mr Tony Kay had a similar experience whilst driving a truck through Tatenhill towards Rangemore. At first glance, he thought a white polythene bag was caught in a hedge on the right side of the road, but he quickly realised something strange was happening. As he drew closer, it looked more like a ball of fog made up of vapour rings. It was a beautifully clear June morning, and there was no sign of fog or mist anywhere other than this mysterious ball. He slowed the truck down to a crawl, his eyes fixed on the apparition, struggling to make sense of it in his head and feeling a more profound sense of cold and fear with every passing second. Then, when he was almost in line with the strange round shape, it suddenly darted into the road. Tony hit the brakes, but it vanished in front of him. He stopped and looked back, but it was gone. Tony remarked that it was around the size of a small child. Could it be the unfortunate spirit of a road accident victim?

Tutbury

Tutbury Village

Less than ten minutes' drive to the northwest of Burton lies the village of Tutbury, which, despite its relatively small size, seems riddled with ghosts. Weird noises and self-moving furniture are a common Tutbury occurrence, with many villagers claiming to have seen full apparitions: a young boy in Victorian clothing, a man in a beige suit and even soldiers, clad from head to toe in suits of shining armour, marching through people's living rooms. With over 3,000 years of occupation on the land, it is hardly surprising that the historic village of Tutbury really is exceptional when it comes to ghosts. A *Derby Telegraph* feature in August 2020 deemed it Staffordshire's most haunted village.

Tutbury Village, overlooked by the historic castle, is reputedly Staffordshire's most haunted village. (Author)

Tutbury is known almost exclusively for its castle, but the village boasts other notable intrigues. The Court of Minstrels was held in Tutbury annually from sometime in the fourteenth century to encourage and regulate the works of musicians from the surrounding counties. Part of the annual court meeting, chaired by an elected King of Minstrels, included a bull run, the cruelty and destruction caused by which led to the court being abolished in 1778. (Author)

Tutbury Castle

Tutbury is most well-known for its castle, which has been intrinsically linked with Burton-on-Trent for over 700 years.

In March 1322, thousands of soldiers under the command of Thomas of Lancaster gathered around the castle, ready to do battle against the unpopular King Edward II during the Despenser War (1321–22). Heavily outnumbered, Thomas marched his forces to the western end of Burton Bridge, where the narrowness of the medieval causeway would limit the advantage of the King's larger army and, fortifying his side, prepared its defence. Little did Thomas know that the King arrived in Caldwell, 5 miles south of Burton, and sent only a small troop of soldiers to attack the bridge. With Thomas busy defending the bridge, the King waited until floodwaters receded enough for his army to cross the Trent at Walton-on-Trent. Learning of this, Thomas initially sent his troops to meet Edward's army outside of Burton, but turned and fled when he realised how substantially outnumbered he was. On his retreat, Thomas deposited a vast treasure at Tutbury Priory to protect it from looting. It disappeared from historical records until the 1830s, when workers discovered a hoard of coins and treasure nearby in the River Dove.

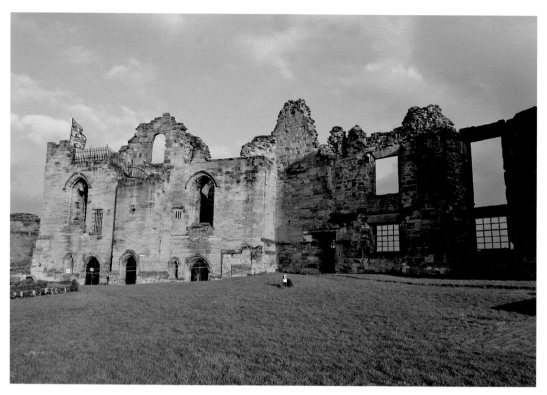

The South Tower at Tutbury Castle. (Courtesy of Simon Deacon)

The castle is best known today for its association with Mary Stuart, Queen of Scots. After an unsuccessful attempt to regain the throne from her infant son, King James VI of Scotland, she fled to England to seek protection from Queen Elizabeth I, to whom she was related through her great-grandfather, Henry VII of England. However, Elizabeth believed Mary to be a threat, especially after Mary had previously claimed the English throne as her own. Instead of helping Mary, Elizabeth confined her to several English castles and homes, including Tutbury Castle, where from 1569 onwards she remained imprisoned for the next fifteen years. Of the many castles Mary stayed in, Tutbury was one of her least favourites, complaining of the damp, wet plaster and draughty, ill-fitting, old carpentry. Yet, despite being a place she despised, her ghost is one of many regularly seen at the castle.

In 1984, one of the former castle custodians, Barrie Vallans, described some of his experiences after living there, day and night, for the previous five years. He believed the spirits of the castle appeared most frequently to strangers, as if trying to reject them. Barrie and his family moved into the castle's living quarters with their nine-year-old boxer dog Bella. He noticed that she refused to go through the main gate, growling whenever near the ancient passageway. Sadly, after only six months, he found his beloved Bella drowned in the river. 'It was as though the castle didn't want her and got rid of her.'

The apparition of a taunting monk appeared to him on no fewer than three occasions. During the middle of winter, with the castle closed to the public, Barrie saw

a figure wearing a monk's cassock walking towards the Vine Croft on the south side of the castle. He shouted and gave chase as the monk strode defiantly on towards the Vine Croft, where there was no exit, only a wall followed by a steep-sloped ditch. Barrie came up to the boundary, but the figure had vanished.

Guests, including Barrie's late mother, also experienced the castle's spirits first-hand. She felt a disembodied hand stroke her face and rest on her shoulder. His daughter Lynne, sleeping in one of the haunted bedrooms, was awakened by noises from her record player. She sat up and switched on the light, to see the lid on the player bouncing up and down. Eventually, strange noises, including the unmistakable sound of footsteps walking around the floors above their living room, became so common that they stopped getting up to check its cause.

Schools, keen to learn more about the history of the unique castle, would often visit with groups of children. Mr Vallans would lead the tours but always refrained from mentioning the ghosts to the children. On one occasion, he noticed a young schoolgirl who appeared to be very upset. Her teacher – of the opinion that the girl was just being silly – said the girl was upset because she saw a lady in white up in the watchtower. The White Lady is one of the castle's most frequent and well-known sightings, with many believing her to be the ghost of Mary, Queen of Scots. A white, misty figure has also been seen on the grassy bank around the North Tower several times.

The most significant sighting is from 2004, when a group of around forty men saw a lady dressed in a full, white, Elizabethan gown, looking down at them from the top of the South Tower. Initially, the men laughed it off, thinking a staff member in costume was trying to scare them. However, they were told that none of the staff wore a white gown that day.

A more recent visitor said the highlight of her trip was seeing the current curator, Lesley Smith, standing in the window of the Great Hall dressed in clothes from Mary's era, something Lesley is known to do quite often. That was until another guest pointed out that Lesley was actually standing near the tearoom door dressed in regular clothing.

Another typical haunt of Tutbury Castle is a man in a suit of armour. Sometimes referred to as 'The Keeper', this ghost seems unhappy to have visitors and often shouts at those unlucky enough to see him. One of his favourite spots appears to be in the vicinity of John of Gaunt's Gateway, where he bellows, 'Get thee hence!' to unexpecting visitors.

For Barrie Vallans, the frequency of the ghostly disturbances eventually became so great that in 1986, his family sealed off the upstairs area of their living quarters, leaving it for the spirits to haunt in peace.

Craig Longson's experiences during a visit in 1999 were profound enough to kick-start a life-long passion for the paranormal and the formation of the paranormal group Ghost Hunters of Stoke-on-Trent. It was getting late, and the castle had closed for the day, but the grounds were still accessible via the main gateway. Craig and two of his friends wandered inside and sat on a grassy bank facing the building. As they absorbed the beauty of their historical surroundings, they noticed a curtain in the upstairs window of the King's lodge begin to move. It lifted slowly to the side, as if moved by an invisible person peeking out at the strange intruders on its land. The curtain remained motionless for around twenty seconds before slowly lowering back to its starting position.

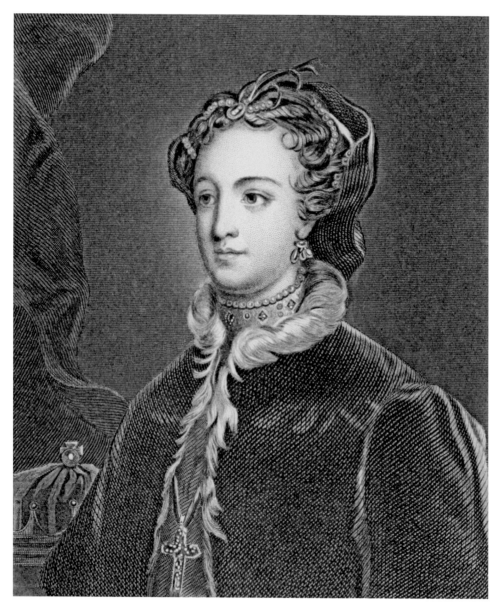

Mary, Queen of Scots was held a prisoner at Tutbury Castle for fifteen years. Despite hating it, hers is one of the most commonly seen ghosts at the castle in recent times. Picture engraved by T. W. Hunt after Farino and published in London by J. S. Virtue

Frightened but intrigued, the men walked over to one of the towers – also still accessible – and climbed the staircase. The sounds of heavy footsteps followed them, and an unwelcoming lady's voice was heard whispering all around them. One of his friends felt the sensation of something pushing against his chest. In panic and struggling to breathe, he ran outside of the castle grounds and waited in his car for the others. He hasn't been back to the castle since.

Julius' Tower, a nineteenth-century folly in the shape of a castle keep. (Courtesy of Simon Deacon)

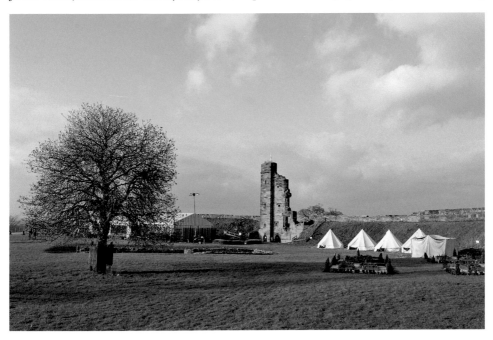

The North Tower, also known as Queen Margaret's Tower, was built under her ownership when it was given to her by Henry VI in 1449 as part of her marriage settlement. The foundations behind the tree belong to a chapel built sometime around the twelfth century. (Courtesy of Simon Deacon)

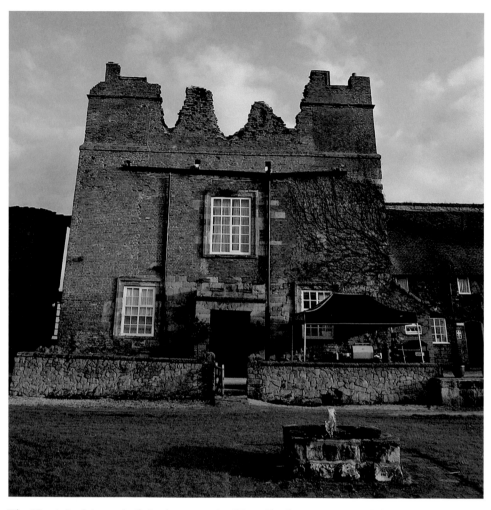

The King's Lodging, rebuilt in the 1600s for King Charles I, is now used for a tearoom on the ground floor and a museum on the first floor. Extensions were made in the early nineteenth century, when the castle was being used as a farm. (Courtesy of Simon Deacon)

End

And thus, our journey through Burton's haunted history comes to an end. From the bottom of my heart, I want to thank you for reading *Paranormal Burton upon Trent*. I hope you have enjoyed it. Next time you cross the Trent Bridge for a trip into the historic town, keep an eye out for something spooky. Who knows, your story could be in a book one day.

Crossing the bridge towards Stapenhill. Underneath the arches, a visible line reveals where the bridge was extended to double its current width in 1926.

A busy day along Burton High Street, *c.* 1905. The Ellis clothes shop was founded in 1864 by tailor John Ellis and rebuilt by his son, Harry, in 1908 as a much larger building that stands on the corner of Burton's haunted market place. Picture taken from a Bass Museum postcard.

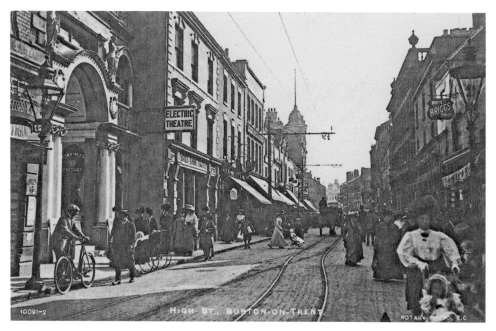

Burton High Street, *c.* 1912. The Electric Theatre was a purpose-built cinema with 750 seats when it opened in 1910. It was later known as the Gaumont, and while the building still stands, the arched entranceway has sadly been demolished in place of a more traditional storefront.

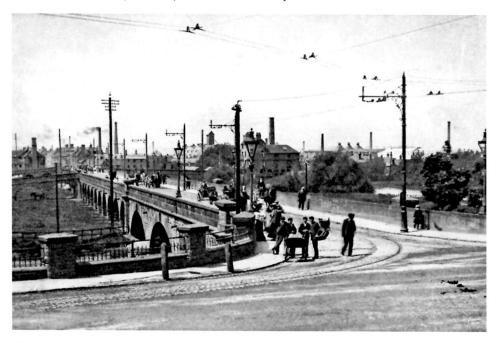

After serving as Burton's main causeway for over 800 years, the medieval bridge was replaced with the new Trent Bridge, which opened in 1864. Trams arrived in Burton in 1903, and the bridge's width was doubled in 1926 to accommodate a growing number of people and vehicles. Picture taken from a postcard posted in 1918.

Notes

1. A search of the death register found one record for a Mr Dykes from Burton upon Trent who died in 1953.
2. This story was originally published in a company newsletter, kindly provided to me by Burton brewery expert Ian Webster.
3. An archaeological excavation in 1997 outside, to the south of the hall, revealed parts of building material, pottery sherds and two complete floor tiles that were dated to the time of the abbey. During a more recent renovation in 2014, work on the floor itself revealed parts of the cloister walkways underneath.
4. A Gaumont Cinema was also located on the High Street, originally the Electric Theatre, which opened in 1910. It was renamed the Gaumont in 1949 until closing in 1956, with the name moving to the Ritz Cinema on Guild Street.
5. R. Stone, 2004, *Burton upon Trent: A History*, Phillimore & Co. Ltd, West Sussex
6. Kim is the founder and admin of On Memory Corner, a successful and popular Facebook group where members research the history of Burton. This group has proven to be a great source of knowledge and several contributors of this book have been discovered within.
7. Her true cause of death is unknown, but one source suggested it could have been Spotted Fever, a tick-borne disease, causing skin blemishes, bearing some resemblance to the bubonic plague.
8. Whilst the murder of Lady Elizabeth is only a rumour, her husband, Philip, once fled to Holland after murdering Francis Wooley in a duel in 1660, later returning to England following a royal pardon.
9. The tale originated in Geoffrey of Burton's *Life and Miracles of St Modwenna*, a medieval manuscript written by the Abbott of Burton between the years 1118 and 1150, detailing various miracles associated with St Modwenna's shrine.
10. R. Stone, 2004, *Burton upon Trent: A History*, Phillimore & Co. Ltd, West Sussex

Bibliography

Books

Stone, R., *Burton upon Trent: A History* (Phillimore & Co. Ltd, 2004)

Acorah, D., *Haunted Britain* (HarperElement, 2006)

Bell, D., *Ghosts & Legends of Staffordshire & The Black Country* (Countryside Books, 1994)

Bell, D., *Staffordshire Ghost Stories* (Bradwell Books, 2014)

Poulton-Smith, A., *Paranormal Staffordshire* (Amberley Publishing, 2011)

Newspapers

Derby Telegraph (Derby, Derbyshire, England)

Burton Mail (Burton upon Trent, Staffordshire, England)

Burton Observer and South Derbyshire Weekly Mail (Burton upon Trent, Staffordshire, England)

Birmingham Gazette (Birmingham, West Midlands, England)

The Expositor (Brantford, Ontario, Canada)

Websites

www.burton-on-trent.org.uk

www.bbc.co.uk

www.emgs.org.uk

www.history.com

www.thecockinnhanbury.com

www.whatpub.com

www.tutburycastle.com